LEOMINSTER
THROUGH TIME
Malcolm Mason

AMBERLEY PUBLISHING

About the Author

Malcolm Mason has worked for many years in education and is currently the Duke of Edinburgh's Award Development Officer for Herefordshire. Away from work, and despite training as a Geographer, his main interest is now researching local history. He is chair of the Eardisley History Group and edited *Eardisley Its Houses and Their Residents* in 2005. Between 2007 and 2009, he was the Project Officer for 'The Reminiscences of Leominster Life' project based at Leominster Museum. Volunteers on this project interviewed older residents in the town to produce a rich collection of Oral Histories, which were published as *Leominster in Living Memory* by Logaston Press in 2010.

Books and Articles

Eardisley Its Houses and Their Residents (Eardisley History Group, 2005)
Leominster in Living Memory (Logaston Press, 2010)

First published 2012

Amberley Publishing
The Hill, Stroud
Gloucestershire, GL5 4EP

www.amberley-books.com

Copyright © Malcolm Mason, 2012

The right of Malcolm Mason to be identified as the Author of this work has been asserted in accordance with the Copyrights, Designs and Patents Act 1988.

ISBN 978 1 4456 0824 2

British Library Cataloguing in Publication Data.
A catalogue record for this book is available from the British Library.

Typeset in 9.5pt on 12pt Celeste.
Typesetting by Amberley Publishing.
Printed in the UK.

Introduction

In common with many market towns, Leominster has seen its fair share of change in recent years. Estates of new housing have appeared, and many more people have moved in. Traditional industries have closed down, new enterprises have taken their place, and buildings have changed use. However, there have been other, more subtle, changes. Leominster is no longer a self-contained community and the reason for the town's early prosperity, the link between the town and the surrounding countryside, is not as strong as it once was.

It is easy to forget how dramatic these changes have been, even within living memory. Recently volunteers based at Leominster Museum interviewed many of the town's long-term residents, and recorded a rich collection of stories and reminiscences detailing these changes. The contributors recalled a time when houses lacked basic facilities and many struggled to make ends meet. But they also remembered close knit families and communities, of happy days, hop picking or wandering the fields, and of May fairs and markets. In this book, I have tried to capture some of these past times and compare them with the Leominster of today.

Early photographers in this town left a rich legacy of images, which has made this task somewhat easier. As have groups like the Leominster Historical Society who have done so much to document the past. However, I would especially like to recognise the work of one group of enthusiasts in preserving the towns heritage, when, in 1971, they bought the old Mission Hall in Etnam Street and converted it into the town museum. All of this was done by voluntary effort and local fund raising, and forty years later the museum continues in this fine tradition – long may it continue to do so.

Acknowledgements

I am grateful to the many people who have helped in so many ways in the preparation of this book. In particular, I would like to thank Richard and Mary Wheeler for giving me access to their extensive postcard collection, and for providing much valued support and advice; The Management Committee of Leominster Museum, for permission to use pictures from their archive; and Robert Oliver for pictures from his collection. For help in sourcing individual pictures my thanks go to Duncan James, David Brown, curator of Leominster Museum, Helen Bowden of Orphans Press, Neil Rimmington of Herefordshire Archaeology, Rhys Griffith of Herefordshire Archive Service, Geoffrey Crofts of Brightwells, Susan Baker of Watson's Motors and Andy Compton of the *Leominster Journal*. I would also like to thank Geoff Brown, Terry Collier, Dennis Davis, Pauline Davies, Michael Evans, Revd Michael Kneen, and Marion Maynard for their invaluable help. Any mistakes in interpreting their contributions are mine alone.

I am grateful to the following for permission to reproduce photographs. T. C. Cole for the photograph of Leominster station on page 76. The 2003 aerial photograph on page 75 was taken by Chris Musson and the image is copyright Herefordshire Council and Chris Musson, HAAS 03-CN-0231. The image is part of an English Heritage supported programme of flying that ran from 2002 through to 2006. The aerial view of Easter Court on page 91 was taken by Derek Foxton and is reproduced by kind permission of Brightwells. The pictures of Orphans Press are from their archive. The view of the May Fair is by Andy Compton. I have tried to contact other possible copyright holders, and apologise for any inadvertent infringements.

For historical sources, I am indebted to the extensive body of work published on Leominster by Eric Turton and Norman Reeves and accounts of Leominster life by Alec Haines, Jane Weyman-Jones and Vera Powell. Publications by the Leominster Historical Society and by Tim Ward, Ron Shoesmith and Roger Barrett, and Alan Brooks and Nikolaus Pevsner provided much valuable background information.

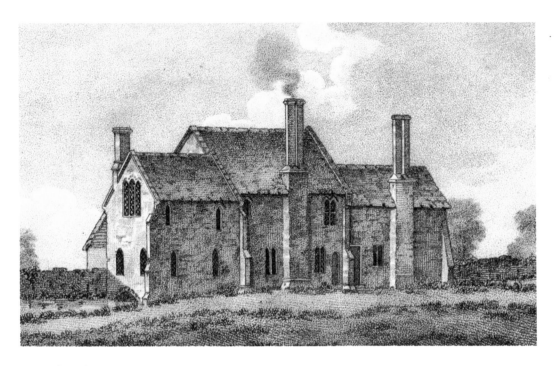

The Priory House

The drawing of the Priory House is from John Price's *The History of Leominster*, first published in 1795, and recently re-published by the Leominster History Study Group. The print shows the Pinsley Brook flowing beneath the building, engineered in the early thirteenth century to provide water and sanitation to this monastic infirmary. In Price's time, the building became a union workhouse or 'house of industry' and, when a new workhouse was built nearby, this building was incorporated as dayrooms and dormitories. Despite having an attic inserted, the building still retains many of its original features, and is now used as a youth hostel.

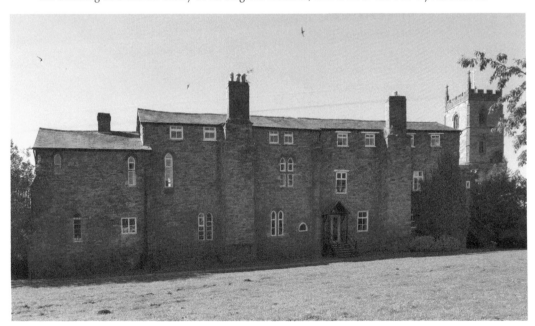

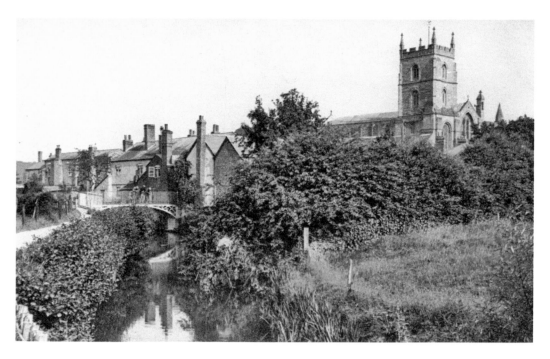

View of the Priory Church Across the Kenwater

This pleasing view has featured on many postcards over the years. Despite the loss of the meadows bordering the river, the footpath is still there. Walking along it offers glimpses of the wider scenery through the trees, before leading to the well-maintained bridge, still proudly proclaiming its manufacture by the Worcester Foundry in 1844.

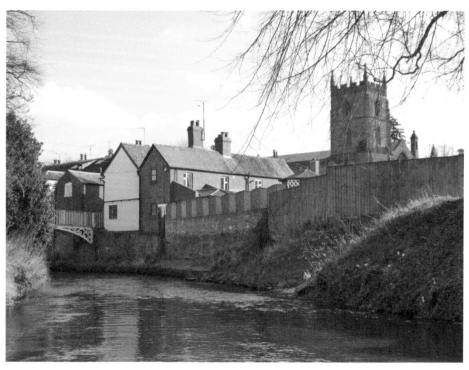

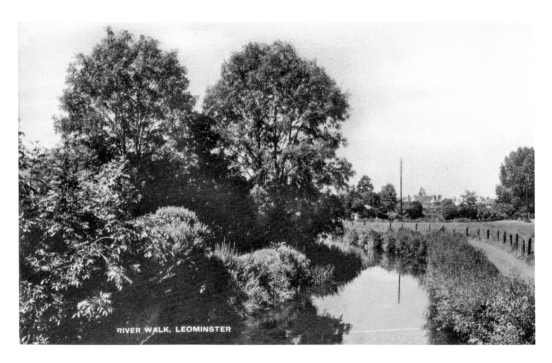

RIVER WALK, LEOMINSTER

River Walk & Mosaic

The Victorians took delight in the town's riverside walks. Sadly, these have declined – the victims of development and the expense of maintenance. However, steps are being taken to restore this area, and the most inspired of these was a 2006 community project by Angela Pendleton and the artist Janice Barrett to create this stunning work of art. Supported by Leominster in Bloom, Heart of England in Bloom, HSBC and the Woodland Trust, nearly 2,000 people of all ages contributed to its construction.

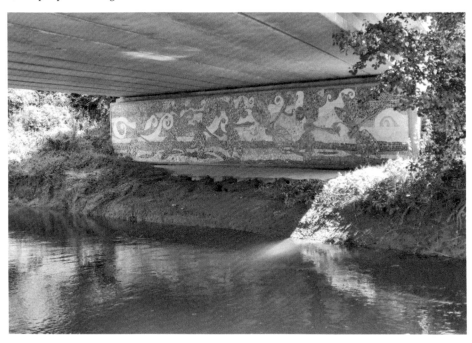

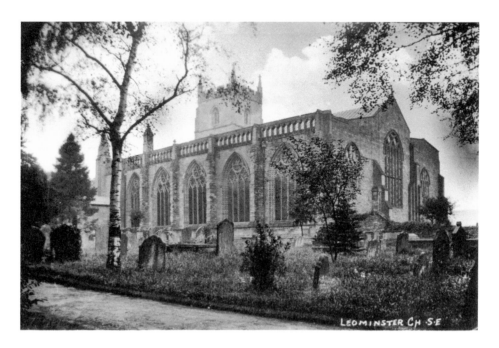

The Priory Church from the South East

The Leominster Priory can trace its history back to about 660. Originally a monastery, the earliest part of the building is the north nave (visible on the far right). However, the church was much altered by the Reformation, repairs, following a fire in 1699, and restoration in the late nineteenth century. From the outside, such changes are less obvious in these photographs. The main differences here are the remodelling in the 1920s of the rather plain east window to include a rose window and the removal of the tombstones.

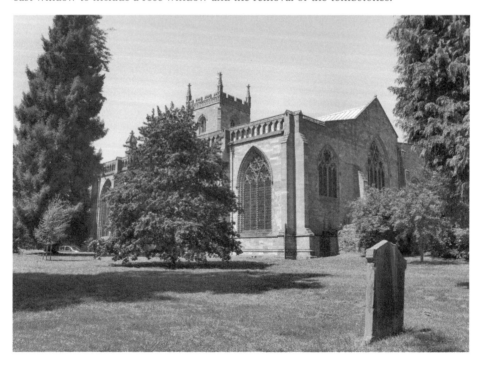

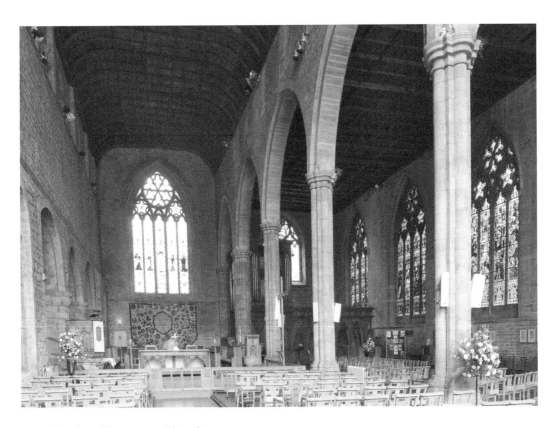

Interior of the Priory Church

The extent of the restoration is much more evident in these photographs. Taken in about 1860, the older picture neatly captures the appearance of the nave just before the extensive work overseen by Sir Gilbert Scott. Scott removed the galleries built between 1722 and 1840, and replaced the pillars between the central and southern naves. This work was carried out in stages, and culminated with the removal of the organ to the south nave.

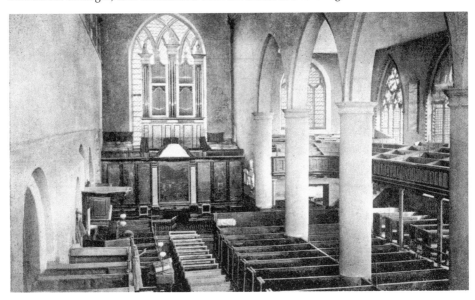

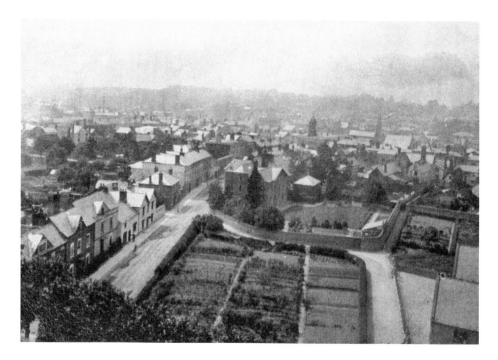

View from the Priory Tower

In this view from the late 1800s, Forbury House and its walled garden (formerly the Borough Pound) dominated the foreground, with the tower of the town hall in Broad Street in the background. The roof of the National School (opened in 1848 and now a community centre), is just visible in the lower right hand corner with the Priory wall marking the boundary of the original precinct beyond. Today, the houses lining Church Road are still there, but the garden in the foreground has been given over to the new vicarage.

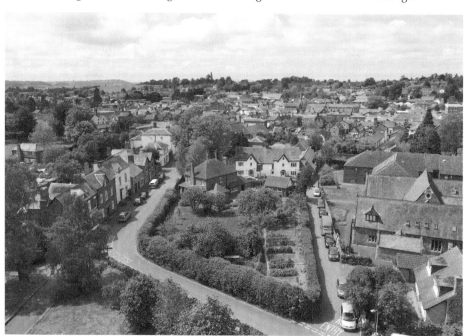

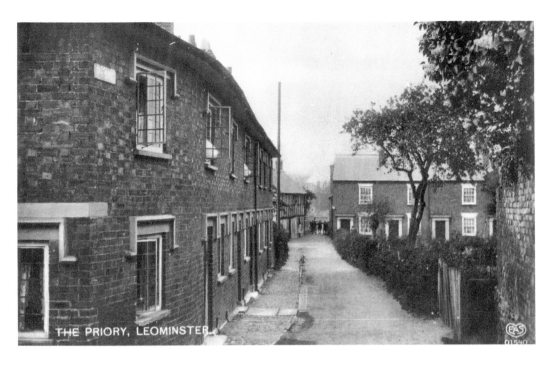

The Priory

An interesting group of houses line the lane that runs from the Kenwater footbridge towards the Priory. Most of them date from the mid-1800s and were built at about the same time as the bridge.

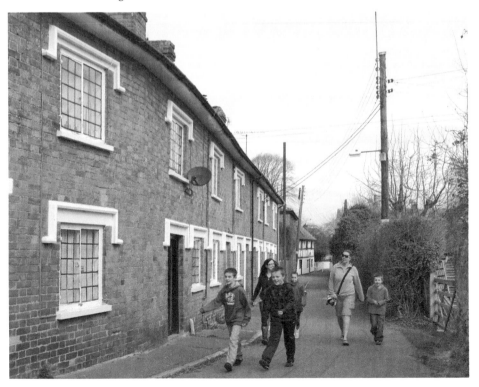

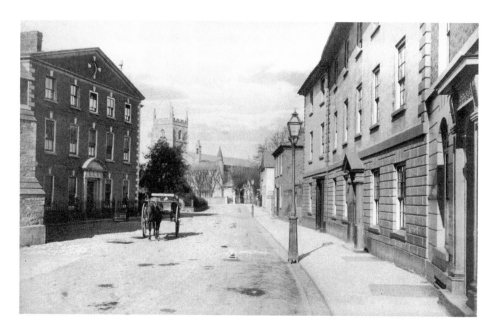

Church Street and the Priory

Outwardly, it is remarkable how little the buildings in the two photographs have changed, despite the 100 years or so that separate them. However, these houses have a rich and complicated history of changing uses. The building on the left, the Forbury for example, is a classic early eighteenth-century town house, which became a billet for Army officers during the war. It was at that time flats, and is now a residential home for the elderly. The modern view captures the start of Leominster's Easter Passion Play. Performed every 4 years, this processional play used 12 locations around the town, and involved a community cast of 150 people.

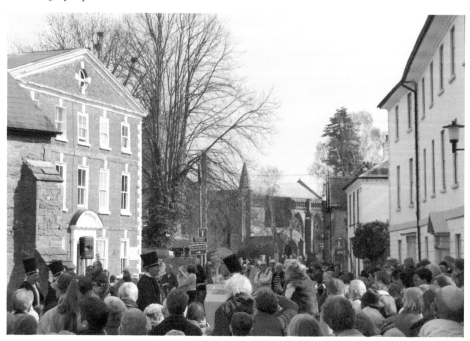

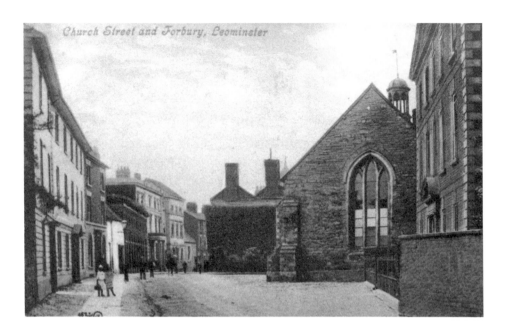

Church Street and the Forbury Chapel

Built in about 1284, the Forbury Chapel on the right is one of three surviving monastic buildings in the town. Of national importance due to its unusual roof timbers, originally it stood at the entrance to the Monastery so that local people would have access to it for worship. Over the years, it has been used as a parish church, the town gaol, the civic hall, and a school. When the older photograph was taken it was used as an office by the solicitor Thomas Sale. About ten years ago, a group of trustees purchased the building and refurbished it as a meeting hall for the church and community use.

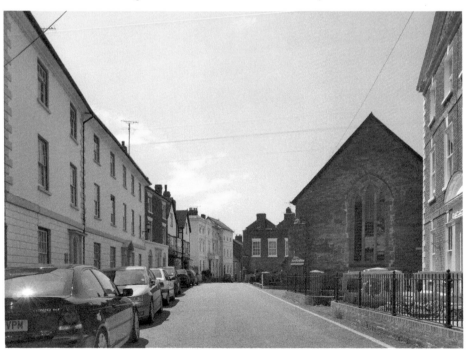

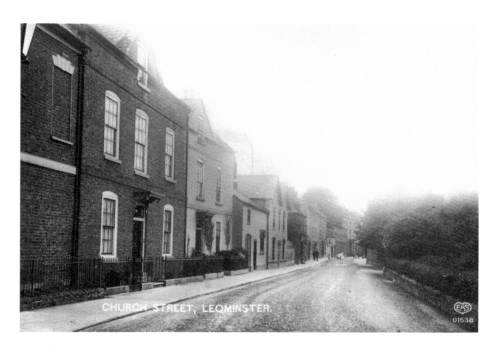

Church Street

This view of Church Street still provides a delightful prospect of Georgian and Victorian architecture. The building beyond the stable block at the mid-point of the street is number 20, the Old Vicarage. In the 1930s this was a small private school run by a Miss Stafford.

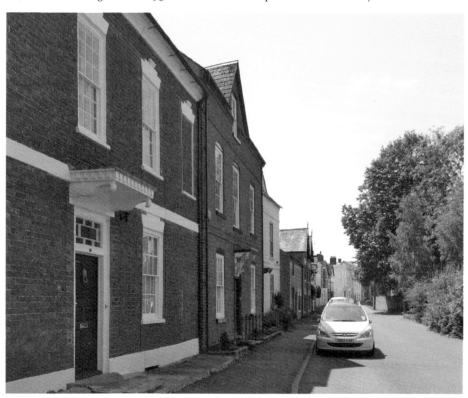

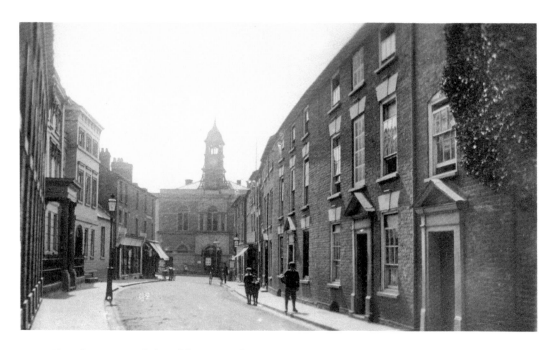

Church Street and the Old Town Hall

At the other end of Church Street, the Victorian town hall dominated the view towards Broad Street. Built in 1855 by the same architect as the Corn Exchange Building in Corn Square (*see page 47*), the front part of the building held the Council Chamber. Behind this was a market hall where, every Friday, all sorts of county produce would be offered for sale. This building suffered a rather sad fate; the tower became unsafe and was removed in 1950, and the rest of the building was demolished in 1975.

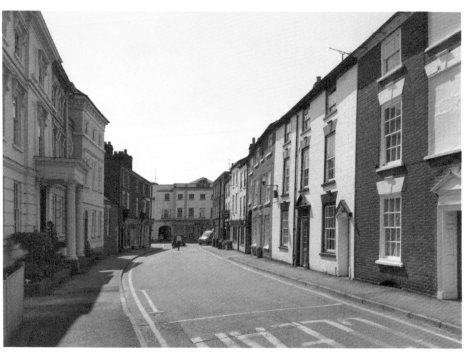

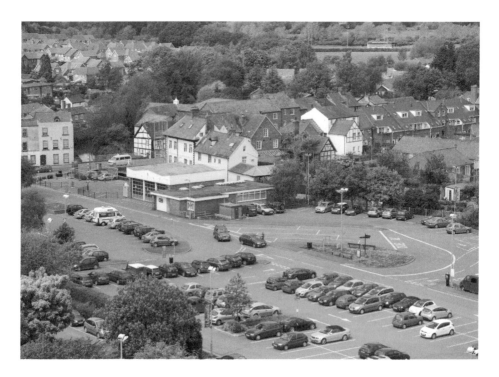

Gas Works

Many of the older photographs in this book feature the distinctive gas street lamps that continued in use well into the last century. The gas was produced at a works on the site of the old Priory Fish Ponds, on the banks of the Kenwater. It is now the site of the town's fire station and a car park. The gasholder at the works had an innovative design that rotated the upper part to adjust for the volume of gas it contained. At one time, it had the name of the town emblazoned across it, and this would point in different directions depending on how much gas was in the holder – apparently much to the confusion to early aviators who used the holder as a landmark on cross-country trips.

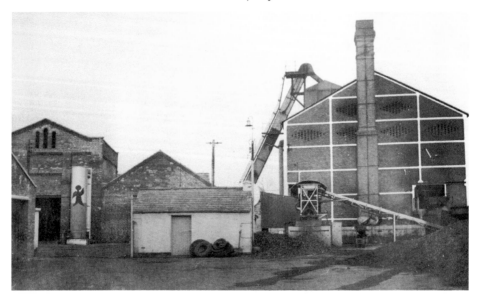

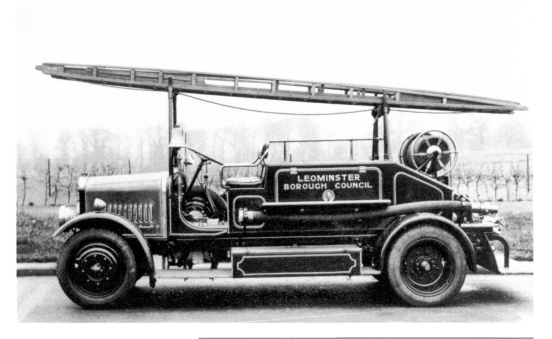

Fire Engine

Fire fighting technology has moved on since this gleaming 1926 Dennis Engine was the pride of the Borough Council. Dennis Davis, a member of its crew, recalls that it did not have a self-starter and had to be hand cranked, before the crew could leap onto the rear platform and hold on to the 'Ajax' ladder as the engine sped away. As the engine only had brakes on the rear wheels, they sometimes lost their footing as it sped around corners and had to tightly hang onto the ladder. This engine went on to see service during the Blitz, travelling to Bristol to reinforce the fire fighting effort after raids. Today, firefighters from Hereford use the Leominster station to exercise with their aerial platform.

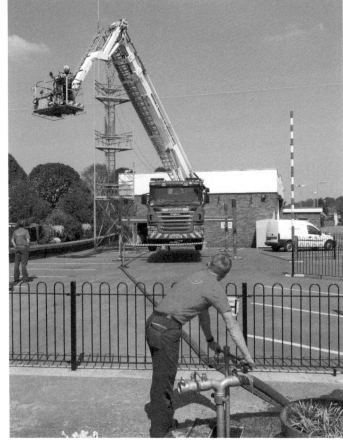

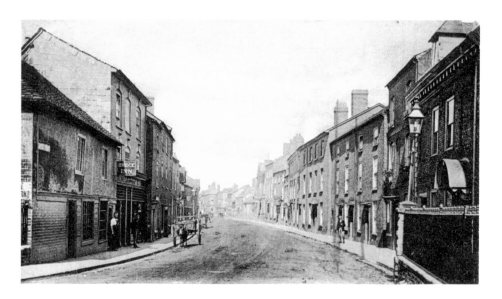

Bridge Street

The view along Bridge Street from the Kenwater Bridge in the late 1800s, appears to show a quiet street of Georgian houses. However, the street was heavily used by traffic, and was host to a number of pubs – ideally placed to fortify travellers. The Bridge Inn was open between about 1850 and 1910. The woman in the doorway may be Eliza Mattingly who took over the pub from her husband George in 1879. Since then the building has been renovated, the timbers exposed, and the jetty on the first floor reinstated. Beyond the Bridge Inn is the Cross Keys, with its sign just visible to the left of the streetlight. This was open until after the Second World War. The other pub in the picture is the Crown & Sceptre at No. 22 on the right hand side.

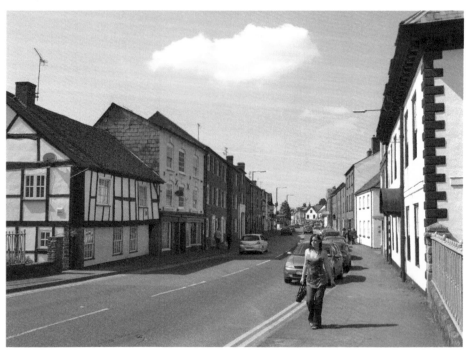

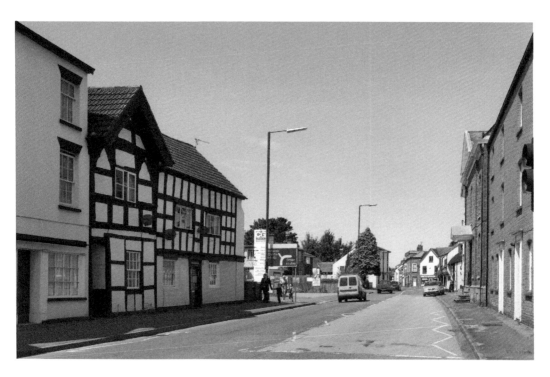

Bridge Street

Although certain key buildings remain, many interesting houses have disappeared from this view. The loss of the group on the left is particularly noticeable; the Royal Commission on Historic Buildings recorded these in the 1930s as being of seventeenth- and early eighteenth-century date. At least the distinctive house on the left, built in about 1400, has been preserved.

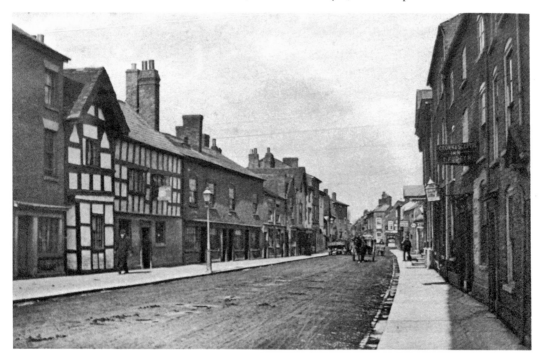

Bridge Street

The railings running down Bridge Street enclose the mill race from Marsh Mill in the far distance of this photograph. On the far left is the Old Tan House, one of the three tanneries placed in this area to take advantage of the copious quantities of water needed to wash the leather. By the late 1800s, the building contractor, Watkins, occupied the site. This business may have been short lived, as it does not feature in many trade directories of the time, and as fate would have it the site is still occupied today by a building supply company.

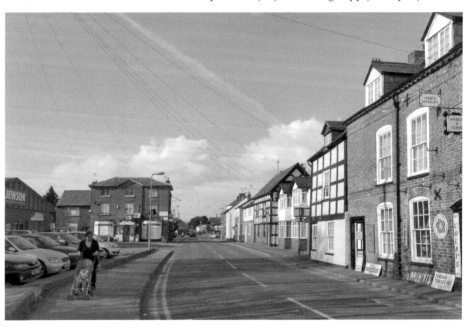

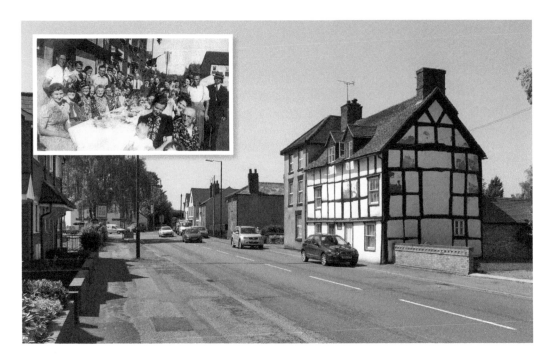

Mill Street

Mill Street from the early 1900s is barely recognisable today. The photographer was standing in front of the Corn Mill that gave the street its name. Just visible in the foreground is the weir that drained the stream to the south when the mill was not in use. This stream was diverted in the early 1960s to control the flooding that regularly affected this part of town. The houses have also changed. Many, including those on the right with one of the occupants in the doorway, have been demolished. The inset shows a 1945 victory party in the street. This photograph looks back towards the mill with the tables set outside the black and white house.

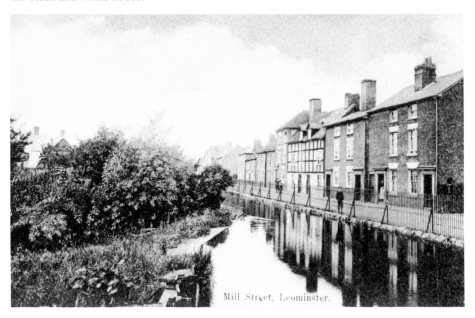

Mill Street, Leominster.

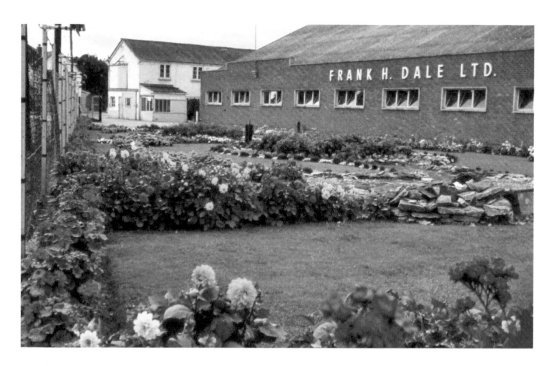

Frank H. Dale

Frank H. Dale Steel Fabricator's are a long established Leominster firm. Founded in 1932 the company's distinctive name plaque can still be seen on farm buildings all over the county. Today the firm are specialists in the design and building of all types of steel framed buildings. In the 1950s the company provided well-maintained flower displays in their gardens bordering Mill Street.

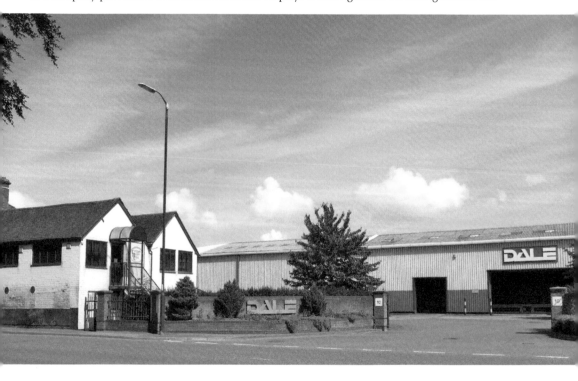

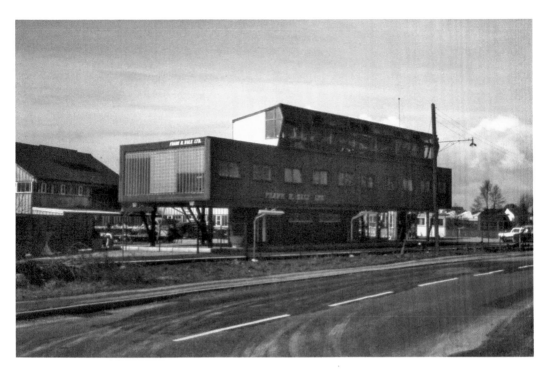

Dales Offices

Dales works in the 1960s extended to both sides of Mill Street. The western side of the road housed the carpenter's shop and these offices were built to the latest designs. The upper section was not a success apparently and was later removed. When Dales closed this section, it was taken over by Rossum & Martin. West Midland Egg Producers owned the factory building in the background of the photograph. This area is now a housing estate, and the Dales building is the site of a DIY warehouse.

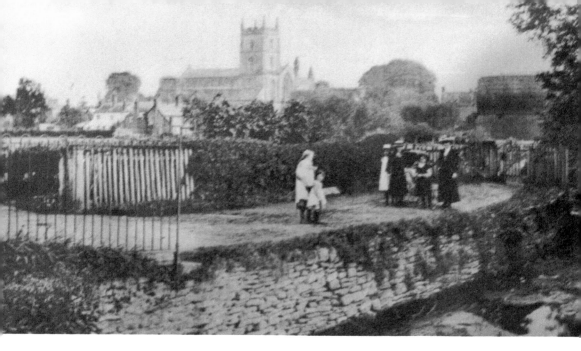

Mill Street Towards the Priory

Another much-photographed scene; the weir in Mill Street and the Priory Church in the background. The mill and the weir have gone, and part of the area is now a sports ground bordered by trees and buildings, but this view across the cricket pitch is close to the original. All Leominster's cricket matches used to be played on the Grange, but were forced to move by concerns about safety.

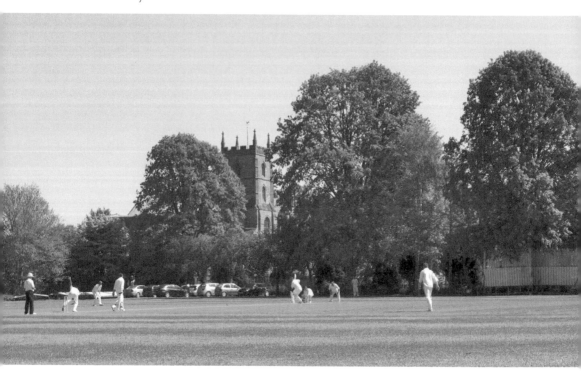

'Poplands' in Mill Street

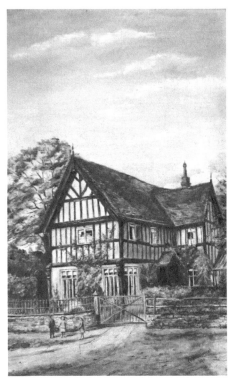

For a time this house had been the office of the Berrington Estate, but this painting by G. Woolnough, 1911, in the Leominster Museum, shows this house as a private residence – a use it retains to the present day. It is a building with some history. Built at about the same time as the town hall (the Grange), it is a reminder of one of the most prosperous periods in the town's history. It probably takes its name from the 'Popeland Turnpike', the gate used to collect tolls at the southern end of Mill Street. This area was once a meeting point for the town Baptists, and they surely would not have approved of the fact that from 1790 to about 1859 this was a public house, called the Old Harp Inn.

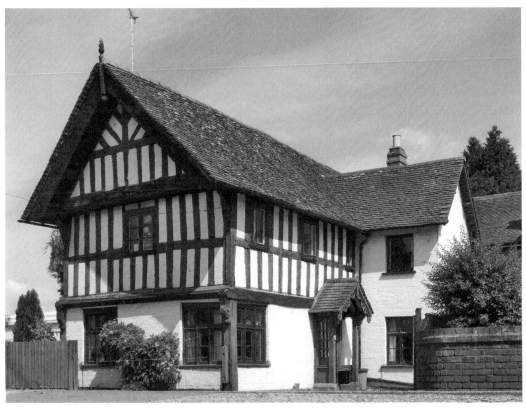

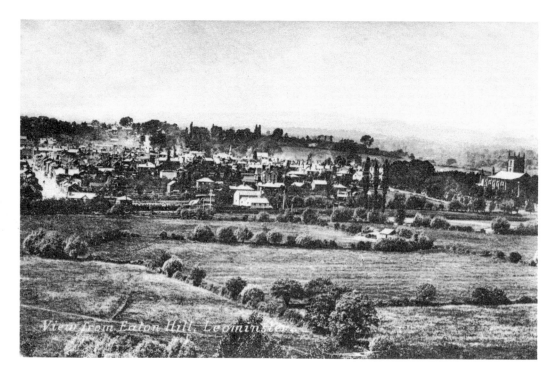

View from Eaton Hill

Eaton Hill has long been a playground for the children of Leominster, and it still offers a fine panoramic view of the town taking in Etnam Street, past the large Pinsley mill in the foreground and the Twin gables of the Grange behind, towards the Priory Church in the north. While the increase in housing development across the town is clear, one of the largest recent projects, the bypass, is unseen – hidden in this view by the line of trees across the foreground.

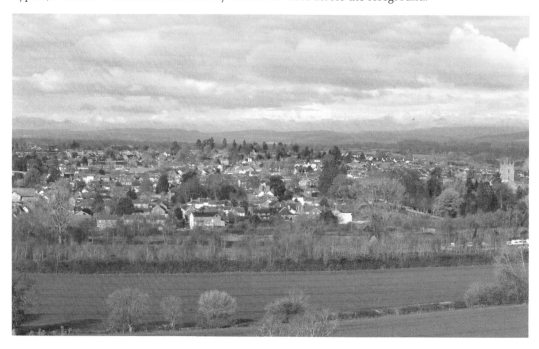

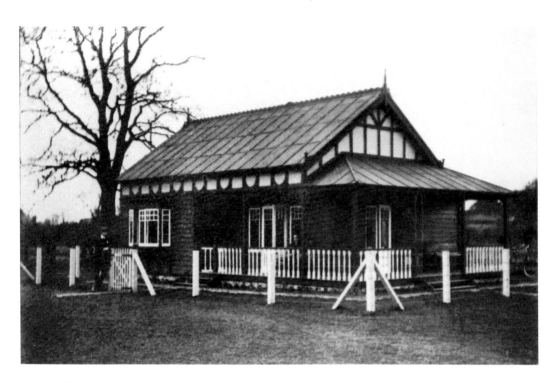

Golf Club

Members of the Leominster Golf Club were proud of their pavilion built in about 1905 at their ground in Steens Bridge. However, the mortgage on the building became a real burden, and twenty years later, the club closed. After a gap of ten years, they moved to their present course at Ford Bridge and the old pavilion came with them, although it has now been replaced by a fine new clubhouse. In the first handbook for the new course (subscription 2 guineas per annum), members were informed that 'a ball landing in any cart-rut, objectionable animal matter, rabbit scrapes etc., can be lifted and dropped without penalty'.

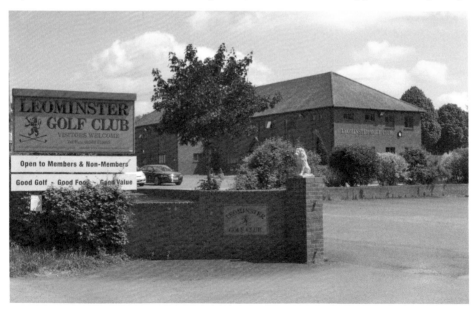

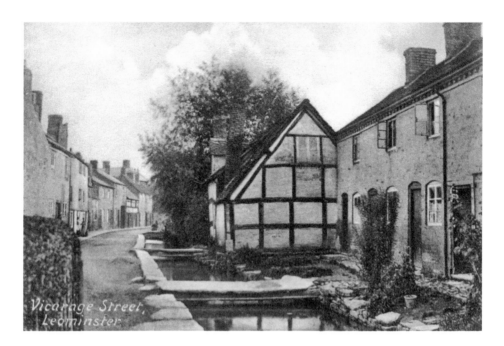

Vicarage Street

Vicarage Street with its little cottages set on each side of the Pinsley provided one of the most picturesque views in the town. Unfortunately, all this has changed. The cottages have been demolished, the river covered over, and all replaced by a car park. Despite the lack of space, in the mid-nineteenth century this area of town was considered a healthy place to live. The cottagers drew their water directly from this river, and as a result, they were less affected by disease than some of the residents of wealthier parts of town who drew their water from contaminated wells.

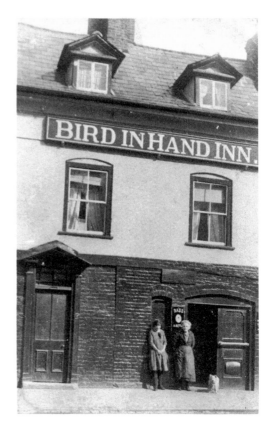

Bird in Hand, Broad Street

This pub was first recorded in 1780 when Mrs Ann Colcomb was in charge. In the photograph landlady Mrs Edwards and her daughter, with Nell the dog, pose for the photographer shortly before the licence was relinquished in 1927. This pub has two links with the Pinsley. Not only did the river flow in a culvert beneath it, but also Robert Mitchell, an earlier licensee had a bottling plant in Vicarage Street – established there to take advantage of the plentiful supply of clean water. The culvert and the bottling plant have gone and the pub is now a kitchen design company.

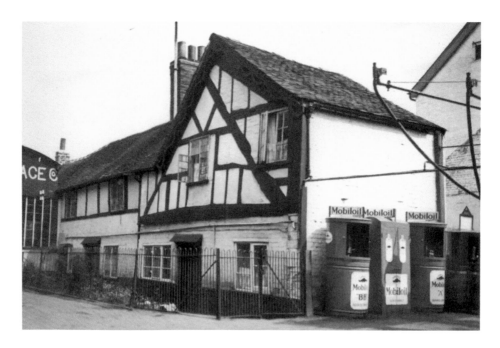

Garage in Broad Street

There are reminders of an almost forgotten age of motoring in this view of the Broad Street Garage. Cars would have stopped on the road to draw petrol from the overhead hoses and to top up oil at the same time. Country garages such as this one were jack-of-all-trades and could repair anything from a bike to a lorry, and as few had electricity at home they even recharged the 'accumulators' or batteries for domestic radios. It is interesting to note that the level of the land must have been much lower in this area when the timber-frame building was constructed. Today, the site has been completely redeveloped, and only the gable wall of the neighbouring house is common to both pictures.

Pinsley House
Looking worse for wear in this picture from the early 1900s, this Georgian house has been lovingly restored, and is now run as a guesthouse. Many of the original features have survived, including the name plaque on the corner and iron rings on either side of the main door. However, the restoration has not retained the 'frames' painted onto the blocked off windows. This feature is often thought to be evidence of an attempt to avoid window tax in the nineteenth century, but in this case it may simply be there to maintain the symmetry of the building.

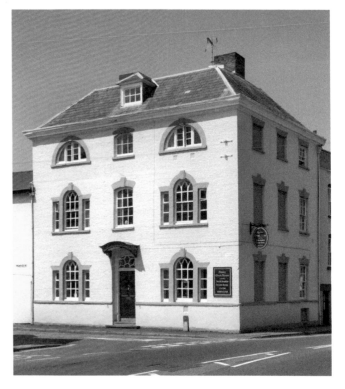

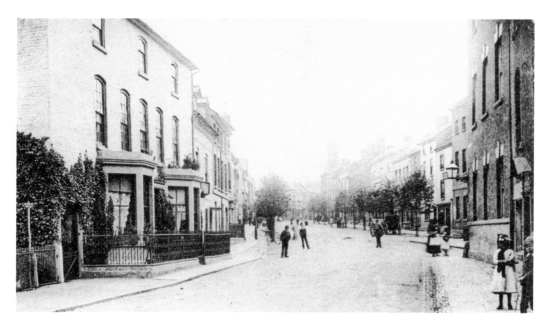

Broad Street

This photograph of Broad Street must have been taken after 1870, when the 'Old House' on the left acquired fashionable Victorian bay windows to enliven its Georgian façade. Since the building of the inner ring road, this area of Broad Street has the feeling of being separated from the upper one-way part of the street.

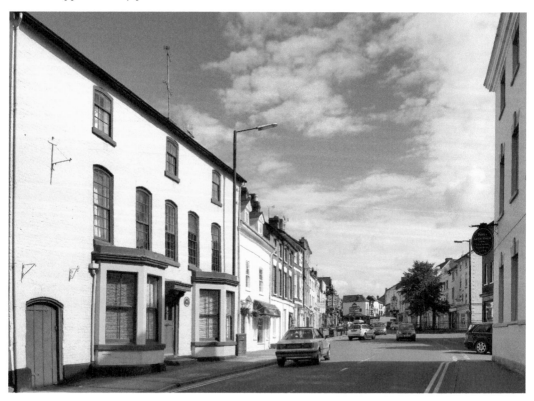

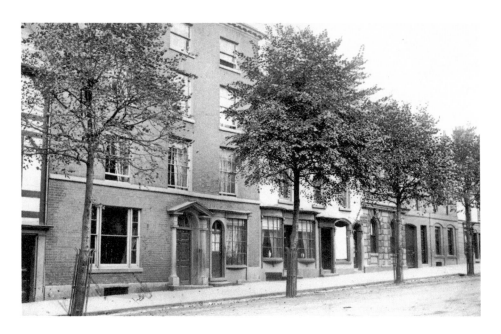

Houses on South Side of Broad Street

Around 1910 this row of imposing houses was a curious mixture of commercial activity and residential gentility. Miss Scarlet lived in No. 24 and George Child in No. 30, with the Alton Court Brewery Company next door at No. 26, Ernest Woods barber shop at No. 28 and Thomas Lewis upholsterers and undertakers at No. 34. Today the area is predominantly commercial and dominated by antique shops – a trade for which the town is developing a reputation.

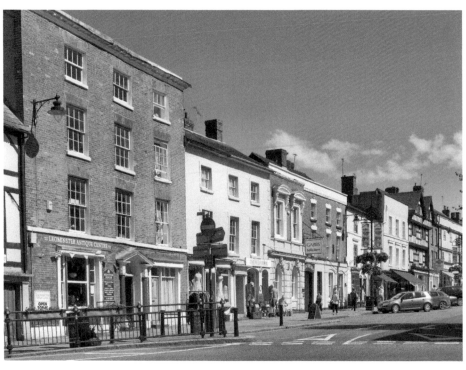

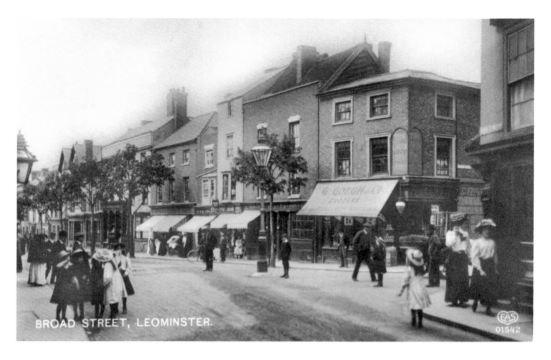

BROAD STREET, LEOMINSTER.

Top of Broad Street and the Grapes

In this bustling scene from about 1910 everyone appears to be in his or her Sunday best – certainly, everyone is wearing a hat. The prominent shop on the corner is Gough's Grocers, a feature of the town for many years. Next door is the 'Grapes'. In the 1850s the landlord was Thomas Smith; he was converted to Christianity and established the Mission Hall in Etnam Street (*see page 73*). He wrote a book about his experiences – *A Brand Picked from the Burning* – and ended up as a Canon in Sydney, Australia.

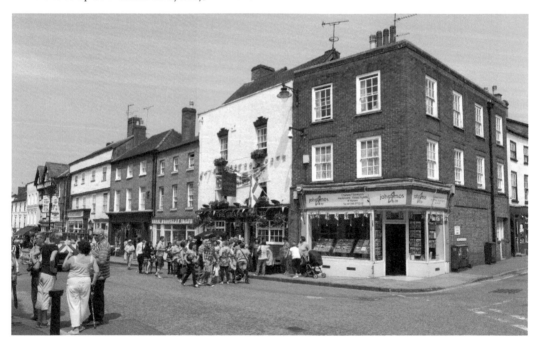

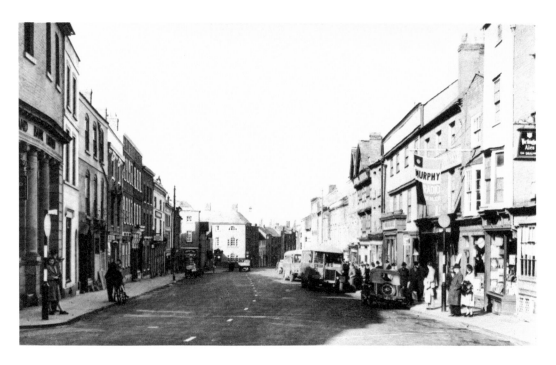

Broad Street

This General view down Broad Street in the 1950s shows the road as a thoroughfare. This was much used by traffic passing through the town, including buses that stopped here before the town had a coach station (*see page 86*). Today the traffic has been reduced, and this area can occasionally be closed to traffic, as here, to allow this space to be used for special events.

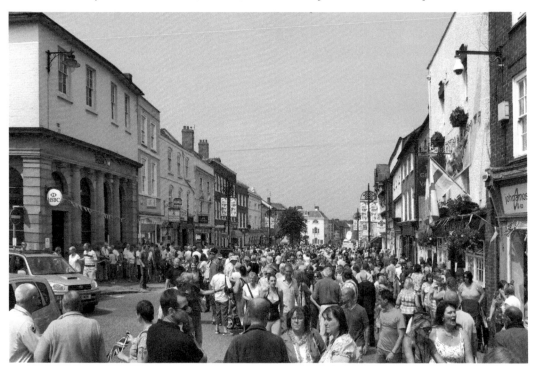

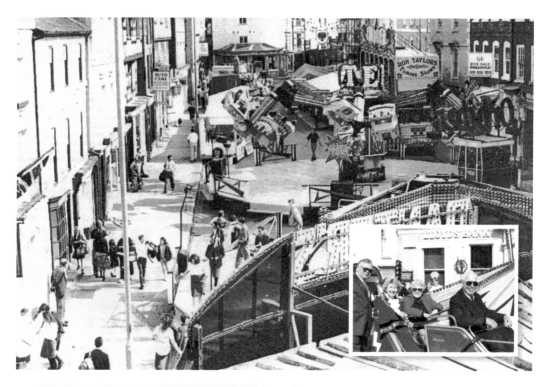

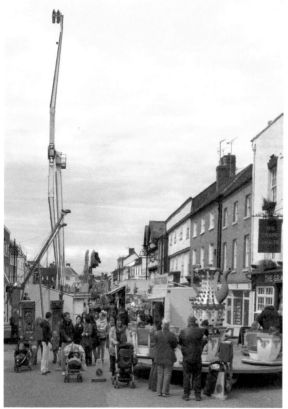

May Fair

The Fair taking over the town in the first few days of May has been a feature of life in Leominster for hundreds of years. Originally, a stock or hiring fair it evolved into the funfair that is known today.

In the 1960s, the showmen were asked to move out of the town until the new bypass had been built – and when the bypass was delayed, the fair did not come back. After a very effective campaign, and some very heated public meetings, the Council voted in favour of the fair and it returned in 1990. Here the fair is shown soon after its return to Broad Street. In the inset, showman Abie Morris and Mayor Pauline Davies entertain visitors from Leominster, Massachusetts in 1994.

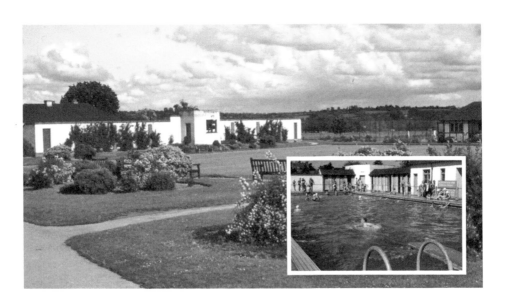

Sydonia Swimming Pool

The sport grounds at Castle Fields were donated by Sidney Bridge for the benefit of 'the children of Leominster forever' in 1937. The open air swimming baths followed later that year, and these were covered over in the 1970s. Maintenance problems led to closure in 2002, much to the disappointment of the town. A public campaign and appeal for a replacement led to the building of new leisure centre and pool. Thankfully the grounds Bridge donated are very much still in use today. The new leisure centre and pool is in the background of the lower picture.

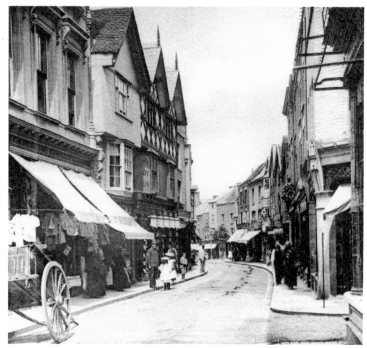

The High Street

The clock on the right in this picture from the early 1900s marks the shop of William Wood, watch and clock maker. Further on is a 'shaving' sign for a barber – a reminder of a time when most men would have a shave at the barber's rather than at home. Across the road is Freeman, Hardy & Willis, a company that retained a shop on this high street up to the mid-1990s.

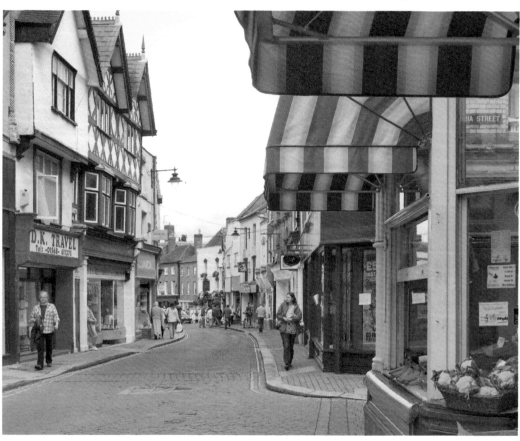

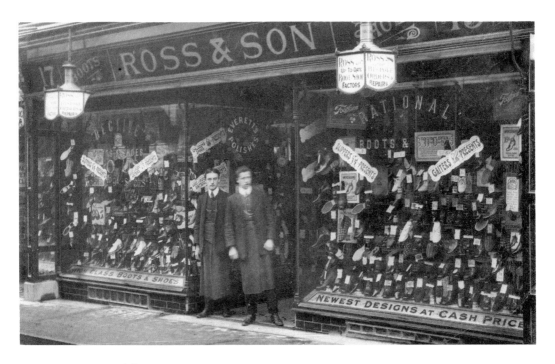

Ross & Son, High Street

This shop, together with Freeman, Hardy & Willis and the family firm of Pugh's, provided footwear for generations of Leominster people. The crowded window display is testament to the range of styles these stores had to offer, providing everything from workers' boots to slippers. The shop is currently vacant, but is soon to reopen following renovation. Thankfully, Leominster has resisted the decline seen in some other High Streets, and there are only a few empty shops. Unlike some of its neighbours, this shop front not been greatly altered, and it even retains the mosaic Ross & Son set into the threshold.

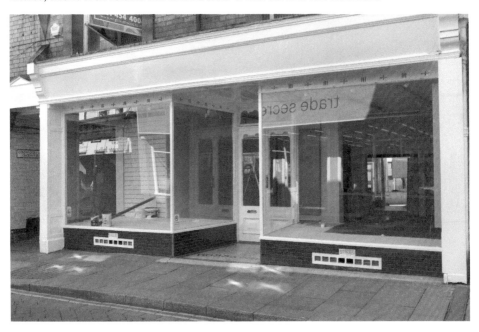

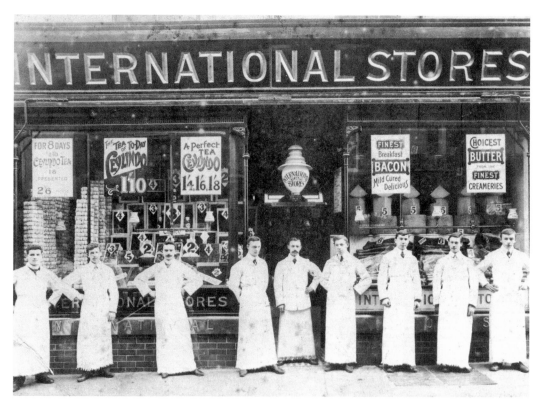

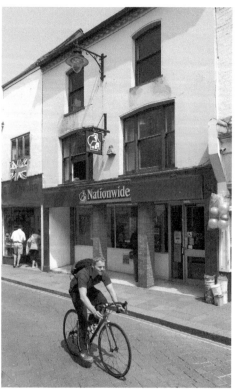

Staff Outside the International Stores

It was something of a tradition for the staff of the International Store to pose outside their shop for an annual picture, and Leominster Museum holds a number taken between around 1890 and 1930. This was a time when shoppers received personal service and their groceries delivered by a boy on a bicycle later that day. Of course, this could not continue, and the shop was eventually forced to move to keep in business. Unfortunately, since then the fine shop frontage has been removed and replaced by a hideous substitute.

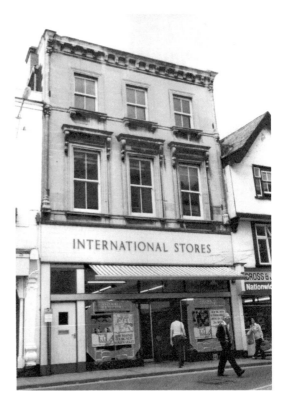

International and Stead & Simpson
To keep pace with changing shopping habits, the International moved to a new site on the High Street and opened the first supermarket in the town in the 1960s. In turn, this was superseded by out-of-town stores and it closed. It is now a Stead & Simpson shoe shop, although the gentleman passing by outside clearly feels no need to offer them his patronage.

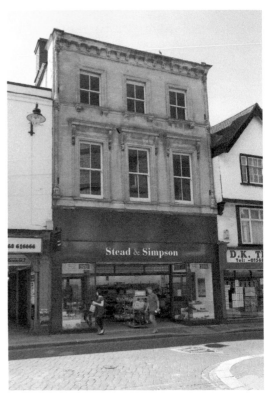

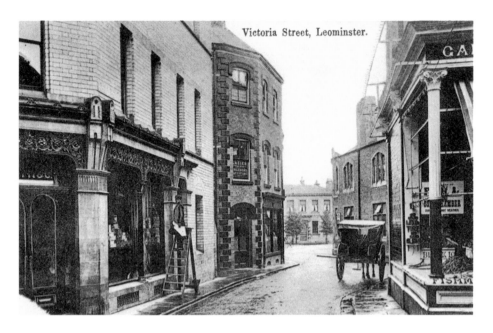

Victoria Street, Leominster.

Victoria Street

Victoria Street is one of the newer thoroughfares in the town centre, created in 1885 by widening existing alleyways and removing buildings. The photograph appears to have been taken during the summer, as the fishmonger is advertising a 'cool chamber during the hot weather' in his open-fronted shop. Few customers seem to be shopping – perhaps they are being kept away by the rain.

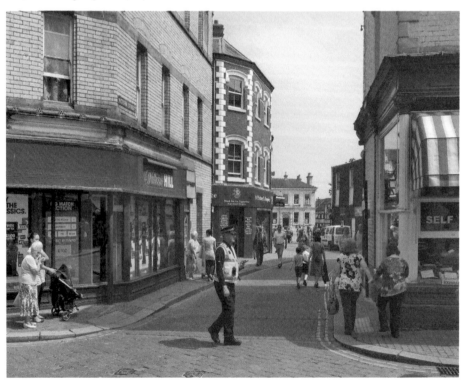

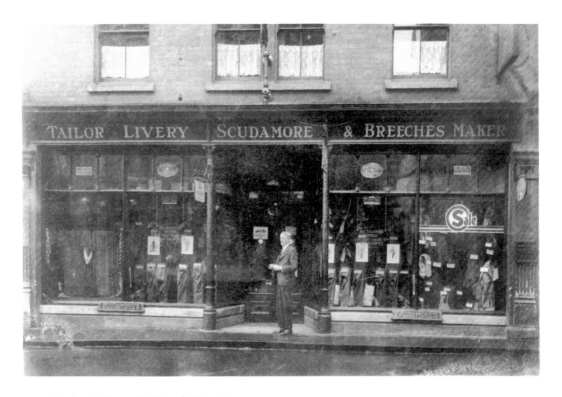

Barber & Manuel, Victoria Street

This building has had a number of tenants. At one time it housed the post office, before the purpose-built office was completed in Corn Square in 1908. The next tenant was Richard Scudamore, a tailor, with a workshop in the rooms above the shop – as the sign in the window boasts. The next owner was the greengrocer's Barber & Manuel; their adverts feature prominently in pictures of Corn Square in the 1940s. The name has been retained, although today the shop is a delicatessen and café run by patisserie chef Eric Celton.

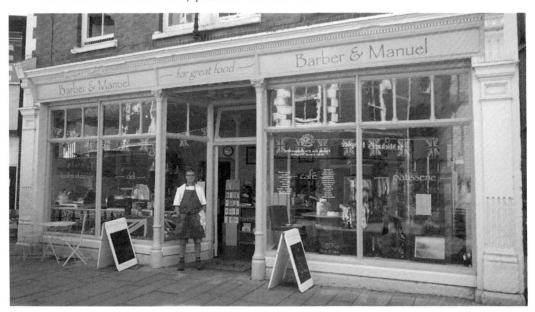

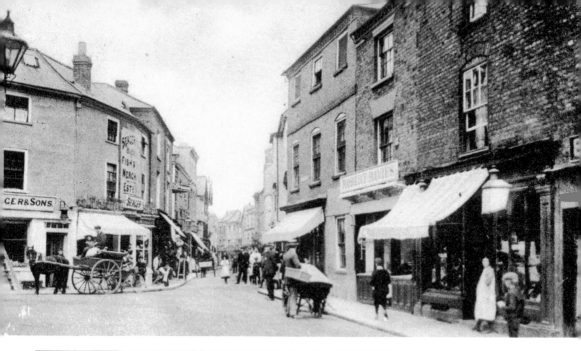

Iron Cross

These are two older views of the Iron Cross between the High Street and South Street, taken in the early 1900s and around 1970. Elizabeth Seager had this shop on the corner of West Street, and another in Etnam Street. Her son William carried on with the business after her. This corner has always been the busiest, and probably the most photographed, part of the town centre. Before the building of the bypass this notorious bottleneck often needed a police officer on point duty to keep the traffic flowing.

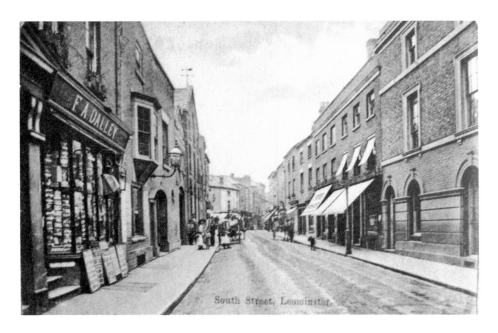

South Street, Leominster.

South Street Towards Iron Cross

The shop on the left was owned by Frederick Arthur Dalley, printer, stationer and newsagent, who at the time also had a shop on the High Street. The curious second-floor bay window beyond, marks the Ring of Bells pub run by Henry Baker in 1890, which is now housing a florists. The building still has a sign for 'Bell Court' above the arch. One building has the same name in both pictures – the Royal Oak Hotel, a hostelry since the eighteenth century, although originally it went by the name of the Unicorn.

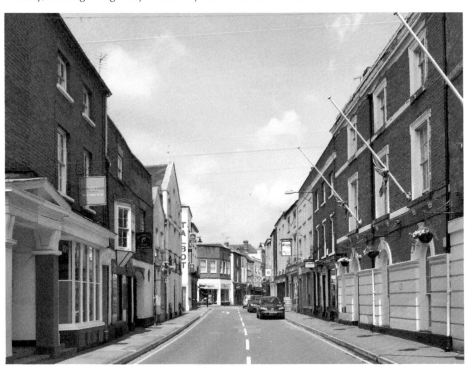

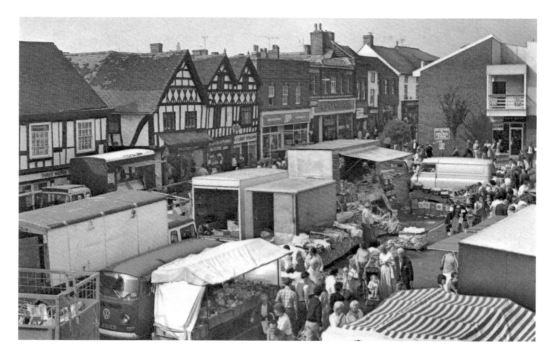

Friday Market in the Corn Square

In the sixteenth century Leominster was described as the 'greatest market town in Herefordshire', and even in the 1930s the town regularly held some of the largest livestock markets in the country. This pre-eminence may have gone, but the market in Corn Square continues to add a splash of colour to the town each Friday as traders spread out their wares to temp bargain hunters. The scenes in the photographs are remarkably similar, although forty years separates them.

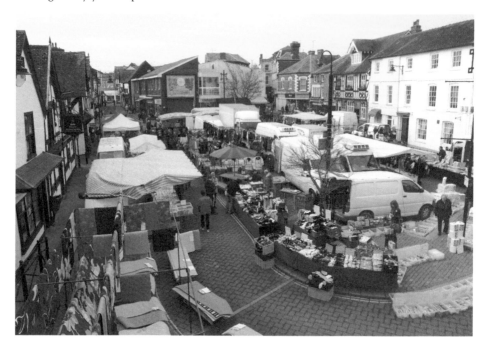

The Corn Exchange

Originally built as a Market House in 1859 the hall of this imposing building could hold 500 people and served as a space for balls, concerts, and films. The advert for the film *Alfie* dates the picture to 1966, shortly before the building was demolished. Its replacement continues to arouse fierce debate, as does the addition of the clock featuring the ducking stool to mark the Millennium.

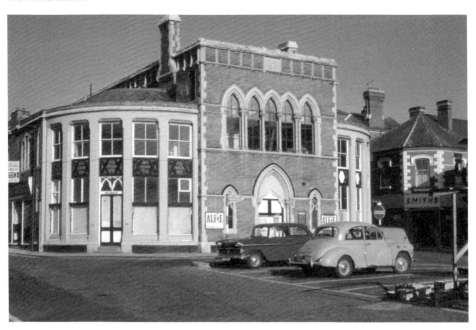

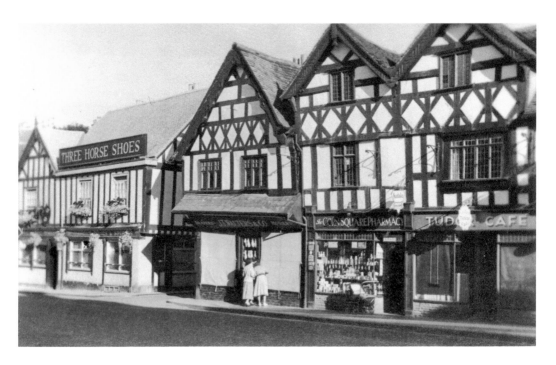

Corn Square South Side

Thankfully, this much photographed group of fifteenth-century buildings still grace Corn Square, and look very much as they did in the 1950s. The shops have changed occupants of course, and the Three Horse Shoes has recently closed – a victim of the downturn in the pub trade.

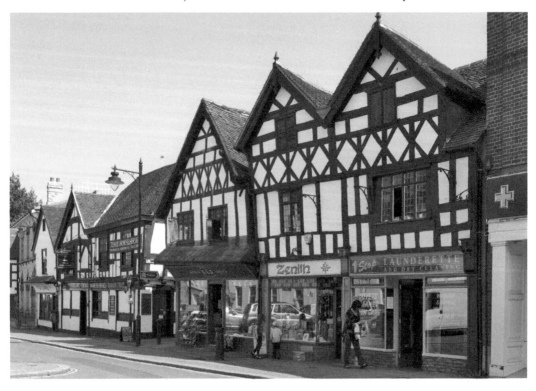

North Side of Corn Square

Two of the buildings in this 1940s view were destined to be the subject of public campaigns to retain them when threatened with closure. Only one was successful. The first was a spirited, but unsuccessful, defence of the post office in 2006. This building has recently re-opened as a pub. The second, following the withdrawal of funding in 2011, was successful in saving the Tourist Information Office and it is now run by a manager and volunteers. It has even retained the model of the ducking stool above the main door.

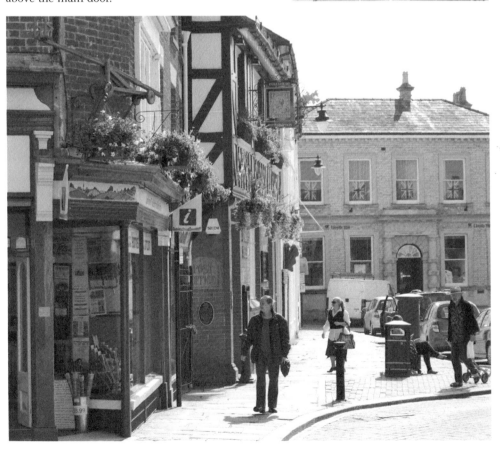

Drapers Lane

Originally, Drapers Lane and the High Street marked the edges of a large triangular market place, onto which the shops and houses on the left later encroached to create the narrow lane we see today. Shop keepers have always used the lane to advertise their wares and entice passers-by and, as you can see, the tradition continues.

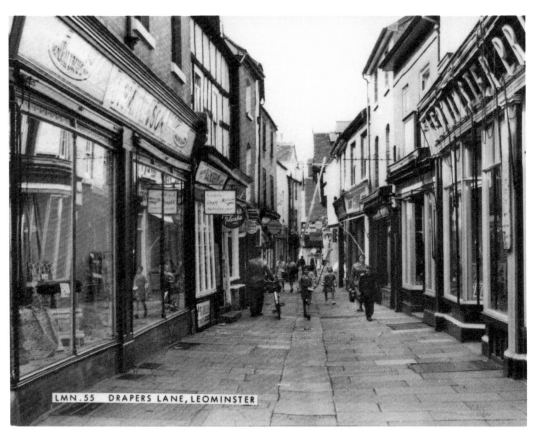

LMN.55 DRAPERS LANE, LEOMINSTER

Drapers Lane

The Leominster Press on the corner of Drapers
Lane and Corn Square not only operated
as a shop selling newspapers, trinkets, and
stationery, but also produced the local paper,
the *Leominster News*. For a hundred years
before it closed in the early 1980s, this weekly
paper provided vital information on local
events.

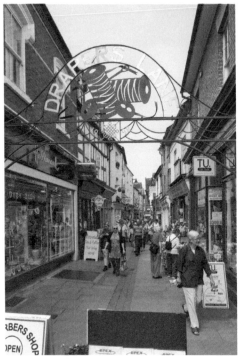

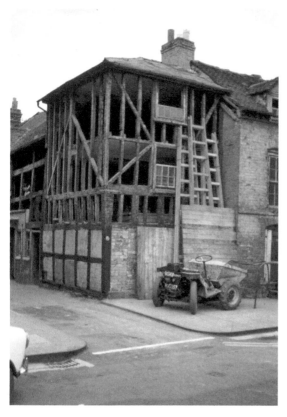

Merchants House

The building was stripped back to its frame during renovation around 1970. Unfortunately, preservation was not the fate of other timber-frame buildings in the town, and far too many have been lost. As Norman Reeves noted in his *The Town in the Marches*, 'Those who like the restorer of the Old Merchants House in the Corn Square preserve rather than replace are the real benefactors of the town.'

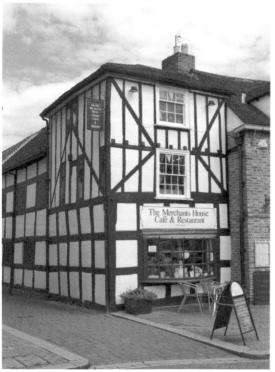

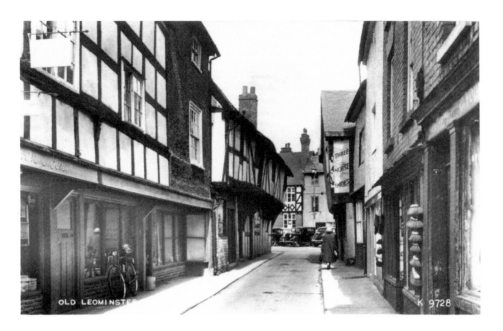

School Lane

Nobody seems to know for sure how this narrow medieval street leading to Corn Square came by its name. Today, it seems to have regained some of the bustle and activity missing from the view around 1950. The café on the left, McEwan's, was the place for school pupils to stop and have a quick lunch, or a place to buy a cake on the way to the Grange to watch the cricket. Many also remember with affection the cosy shop on the right where Mr Young could be found at work; his mouth full of nails ready to drive into the sole of another boot in need of repair.

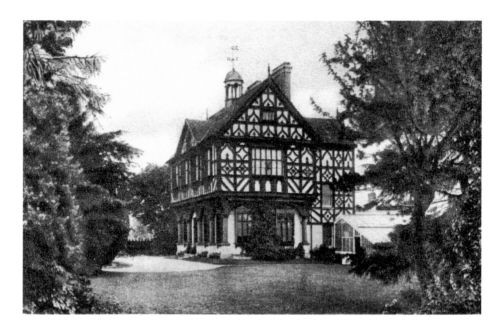

The Grange

Built by the King's carpenter John Abel in 1633 the 'Old Town Hall' originally stood at the junction of Broad Street and High Street. It was rebuilt on this site and this picture was probably taken around 1900 when Mr Henry Moore, a prominent local solicitor, and his family, occupied the building. The building has gone through a number of uses since then and in 2004 the freehold was transferred to the Leominster Area Regeneration Company Ltd (LARC). After six years of, at times controversial, planning, the building work commenced in 2010. The building will be used for offices, as a facility for local community groups and charities, and as the Mayor's Parlour by Leominster Town Council.

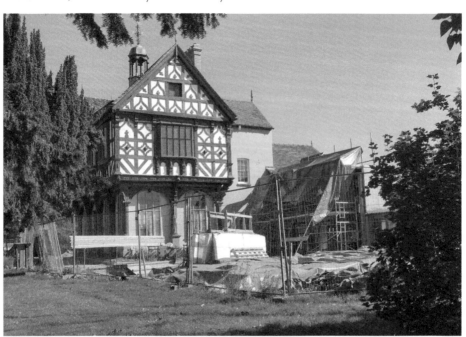

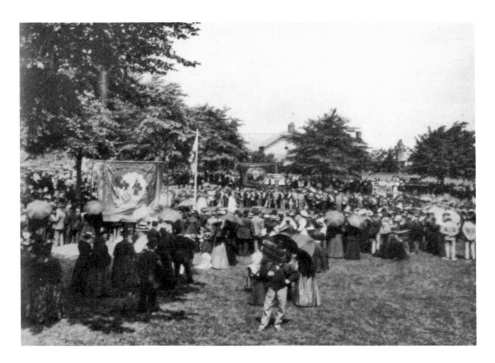

Diamond Jubilee Celebrations on the Grange

On 22 June 1897 the good people of Leominster gathered in their Sunday best on the Grange, and with a military band in attendance, took part in a drumhead service to celebrate Queen Victoria's Diamond Jubilee. Over 100 years later crowds gathered in the same place on 4 June 2012 to celebrate another Queen's Diamond Jubilee with a family fun day.

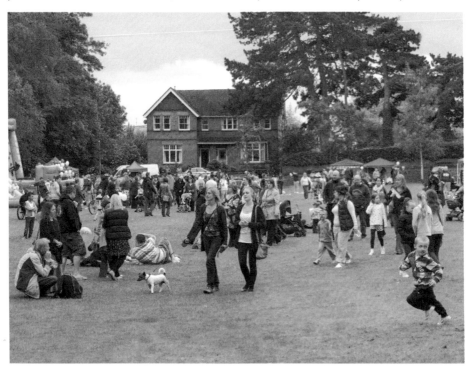

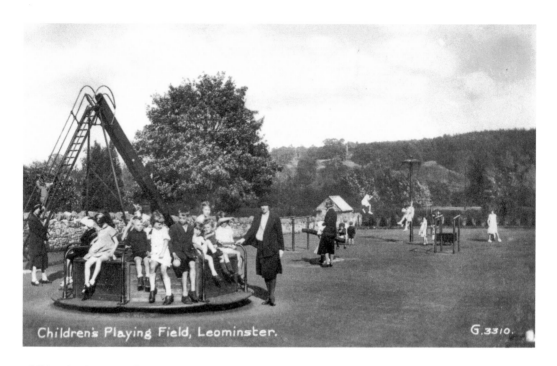

Children's Playing Field, Leominster. G.3310.

Children's Playground

The playground off the Grange was the gift of Stanley Holland, an engineer who left Leominster under a cloud in his youth and returned with a fortune eventually to become the first freeman of the town. In 2009, Leominster Council reinstated a plaque here to commemorate his generosity.

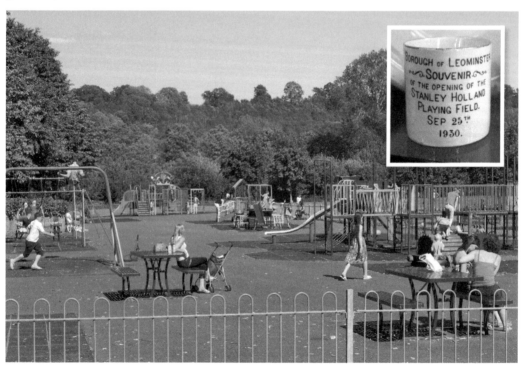

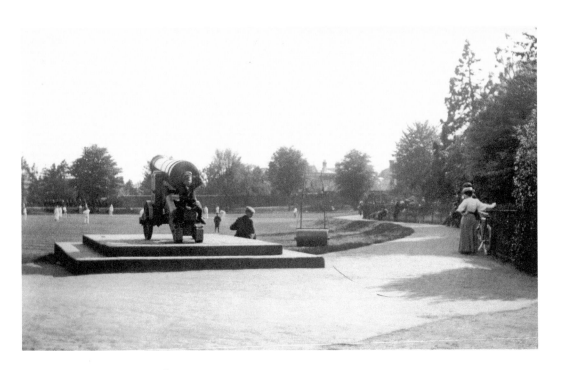

Crimean Cannon on the Grange

There has been some discussion in the press recently about the fate of this relic of the Crimean War. A climbing challenge for generations of children, some in the town still have memories of placing fireworks down its barrel near bonfire night. It seems it was removed during the Second World War for salvage. The large sculpture of the groundsman and his roller are a reminder of the cricket matches here and the evenings when hundreds of people would line the ground to watch knockout matches.

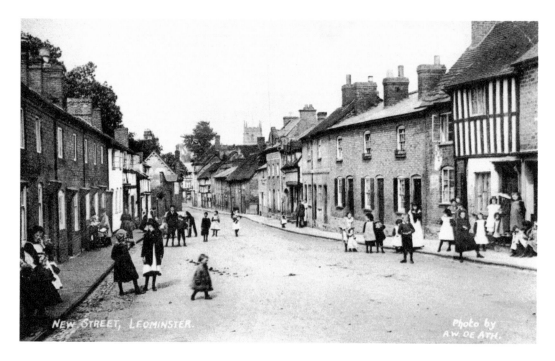

NEW STREET, LEOMINSTER.

Photo by
A.W. DE ATH.

New Street

In the late 1800s New Street was a busy community with many shops, tradesmen and lodging houses. In the centre of the photograph, with a flagpole, is the drill hall of the Herefordshire (1st) Rifle Volunteers where the town's Territorials mustered to march off to both World Wars. This is flanked by an interesting mix of old buildings, including the old Borough Gaol; all of them demolished to make way for the Inner Relief Road in the early 1970s.

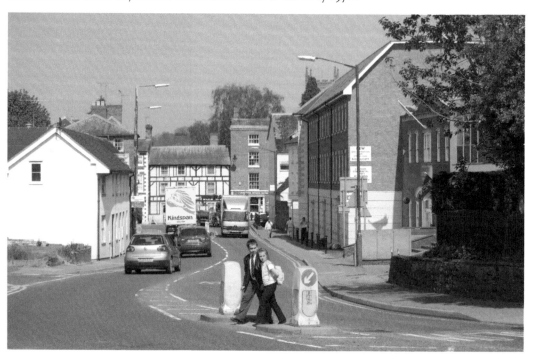

Hinton's Store, Rainbow Street

Hinton's are a long established trading family in Leominster. George Felton Hinton opened this agricultural merchants in Rainbow Street in 1885 and used the occasion of the store opening for some marketing. The mug, now at Leominster Museum, features a detailed picture of the new store and two other illustrated panels. One has a very thin pig – fed on inferior feed, and the other has a giant porker – fed on nothing but Hinton's feed. Most people in Leominster today will know this building as Foster's, the later owners of the building. Today it is vacant, but it retains many reminders of its past, including most of the signage and even the pulley used to raise sacks to the upper floor.

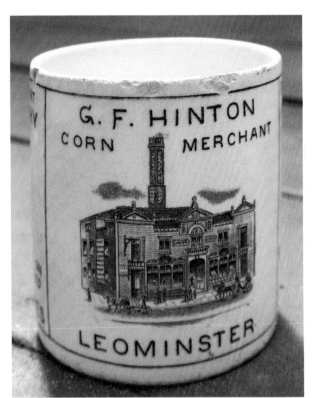

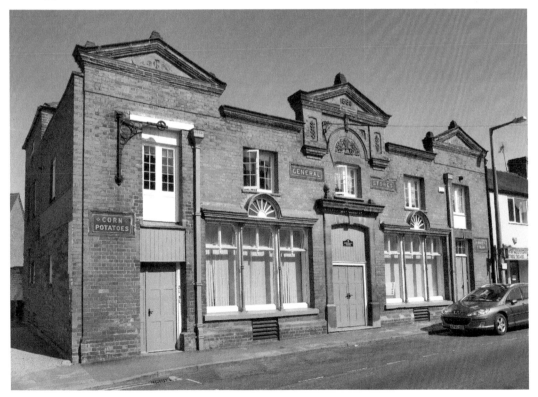

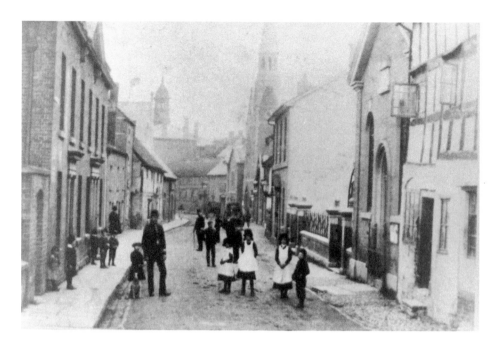

Burgess Street

The presence of two Leominster Borough policemen in this rather fuzzy photograph suggests that it dates from the late 1880s, after the police station had moved here from New Street. At the time of this photograph, the street held three chapels: the Presbyterian (Congregational) with the spire; and across the road the old Wesleyan – sold to the Catholic Church as it became too small for the Methodist congregation. A new Wesleyan chapel was built across the road, to the right of where the group of children are standing. Today this is a hairdressing salon.

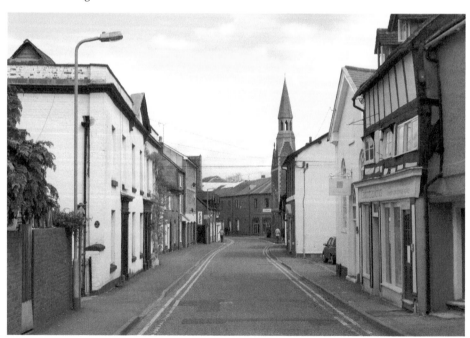

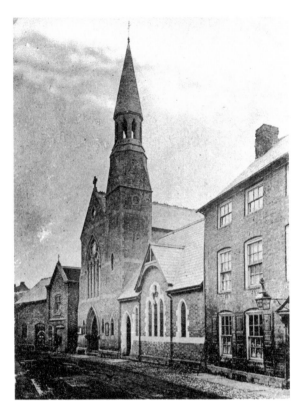

Burgess Street

The tower of the Congregational chapel still dominates the skyline of Burgess Street as it did in the 1890s. Built on the site of an earlier dilapidated chapel, the Church Institute and Sunday School were added later. The old chapel is a shop selling household goods. To the right of the Institute stands the now demolished New Inn, run by John Wilson in 1879, and by Thomas Evans in 1905. This pub had originally been called the Sun Tavern.

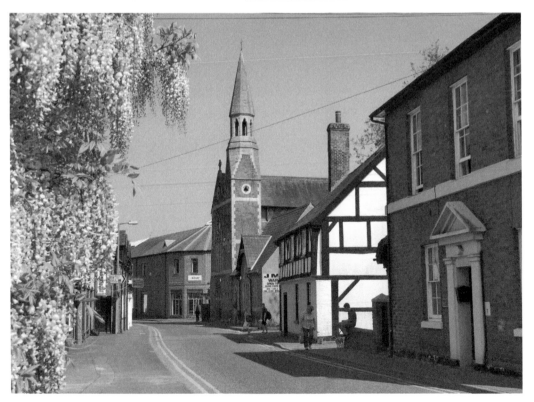

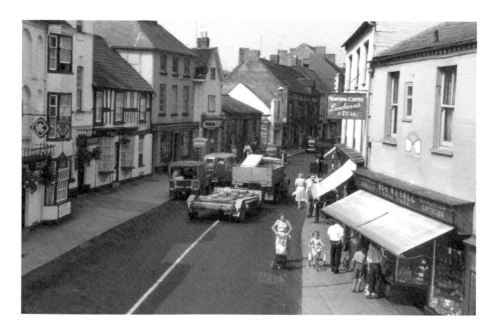

West Street

This 1950s scene will bring back memories for many of a quieter time. A little girl on her tricycle concentrates on negotiating the corner past Hinton's Café, while a schoolboy in shorts has to wait patiently while his parents admire the jewellery on display in Reg Mayall's window. Today, although the shops have changed, they continue to be an interesting mix of small independent traders – and the telephone box is still there.

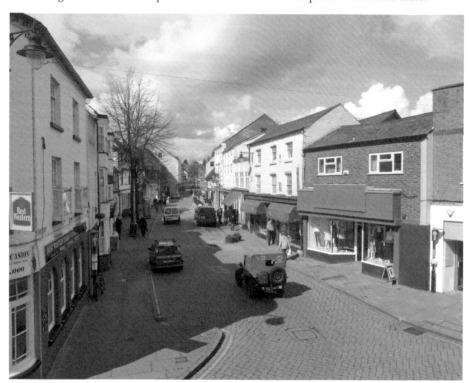

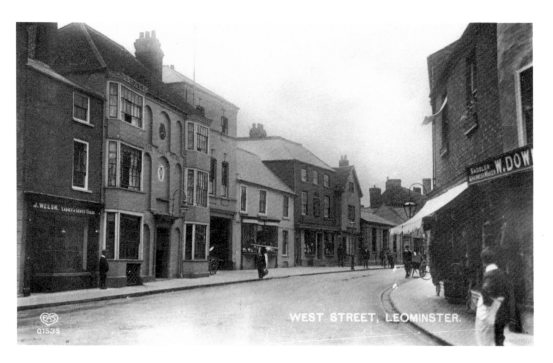

Talbot Hotel

Although the main part of the Talbot was built in the 1600s, it was largely rebuilt in the following century and has been extended over the years. These photographs both show the hotel in past times, around 1900 and 1970. Externally, it only seems to be details that have changed. In the earlier picture, the hotel still retained the large archway for coaches and horses.

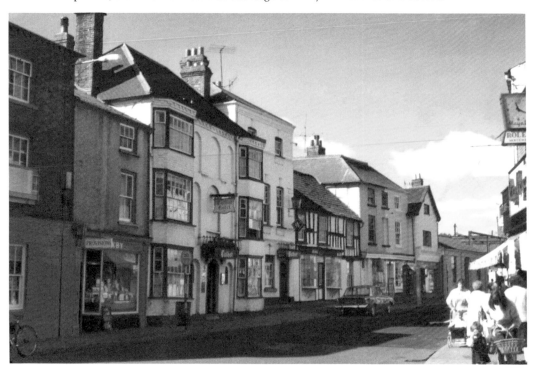

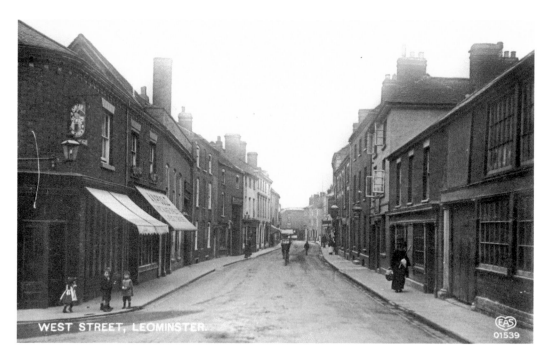

West Street, Looking Back Towards Iron Cross

The awning on the left at No. 44 advertises the premises of Abraham Pool, cabinet maker and upholsterer, in this view from about 1910. The large chimney on the left is probably part of Alexander & Duncan's Vulcan Foundry. This was a brass and iron foundry and manufactured implements for the agricultural market. Access to the works may have been through the large archway – roughly where the entrance to the car park is today.

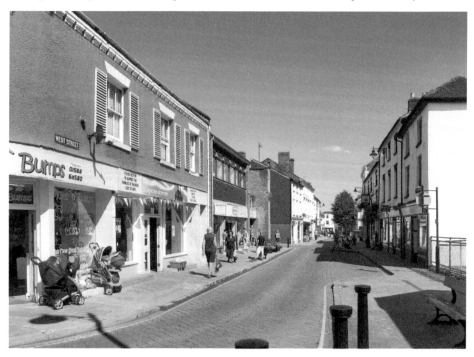

Green Lane

This view of Green Lane in the 1890s captures Army bell tents in the open land on the left – probably a local Territorial or Yeomanry unit on their annual training camp. In the Second World War, the Army's presence in this area became permanent with the building of a small camp here. After the war, these huts were used to house part of the new secondary modern school. Pupils at the time have memories of iron stoves in the centre of each hut as the only source of heating. The building of a new secondary school in South Street released this land for housing.

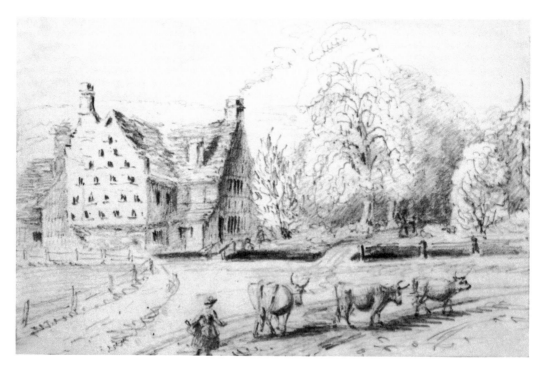

The White Lion, Etnam Street

When Henry Newman completed this sketch of the White Lion in about 1850, the eastern end of Etnam Street was just a quiet spot on Worcester Road. Built in the early 1500s, the original layout of this building is still visible today, although the nest holes for doves no longer adorn the gable wall and the Pinsley brook in the foreground has been covered over.

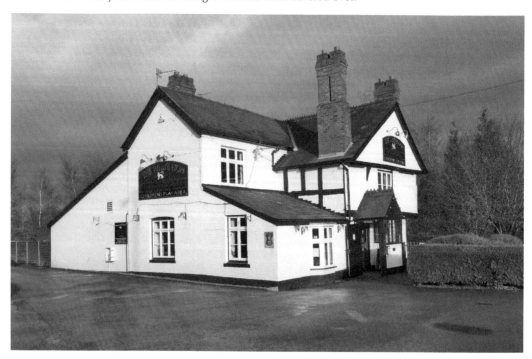

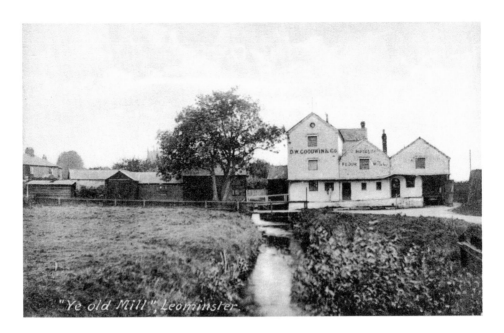

"Ye old Mill", Leominster.

Pinsley Mill

The mill today presents a rather forlorn remnant of what was once a thriving complex of buildings. Originally built to spin cotton, this mill was one of the earliest in the town. It was destroyed by fire in 1754 and replaced by this corn mill. By the time the tenancy had passed to D. W. Goodwin in 1910, an engine powered by coal gas had supplemented waterpower. Curiously, the OS map of 1927 marks it as disused, but some accounts have it working up to the Second World War. For a time it was a furniture showroom and there were plans to convert this building to residential use, but fire and delays have led to such a deterioration that it now faces demolition – a sad fate for this historic site; the last of the five corn mills once operating in Leominster.

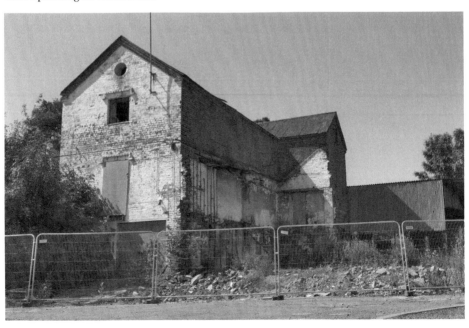

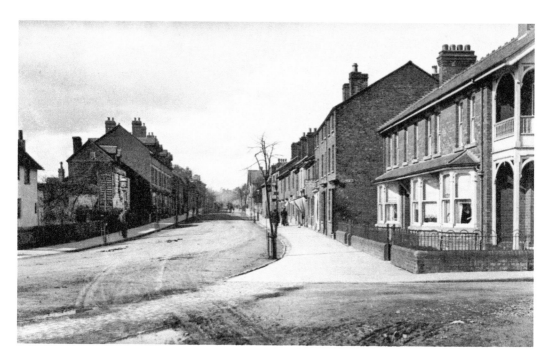

Etnam Street – Junction with Pinsley Road

Nearly the whole length of Etnam Street is visible in this picture from the late 1800s. The presence of a photographer was clearly enough of an event for the occupant of the house on the right to watch proceedings from her front window. Apart from the fact that electricity has replaced gas for the street lighting, and only one of the trees in the foreground has survived to maturity, the scene is remarkably unchanged.

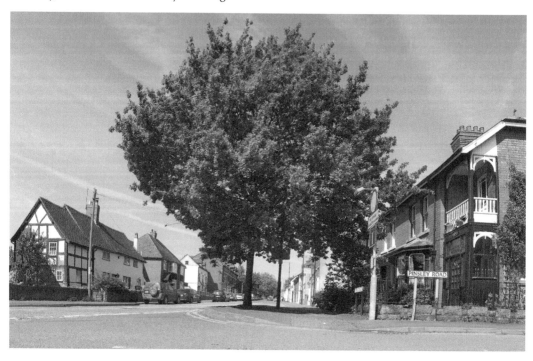

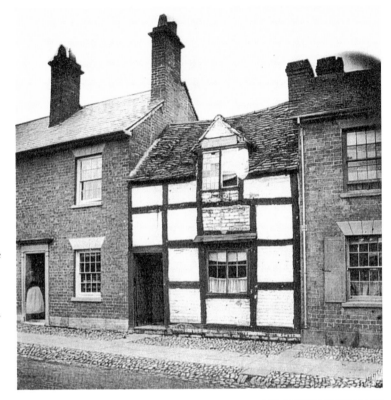

House on North Side of Etnam Street

A snapshot of how housing has changed. The timber-framed house photographed in the late 1800s is a survivor of early housing in the town. The 'front door' gives access to a passageway to the rear of the house and to an internal door to the one room downstairs. Above, the single-room upper floor has been improved by the addition of a gable window. The houses on either side may have been a similar design at one time, but they have gone – replaced by brick, as this cottage would shortly be.

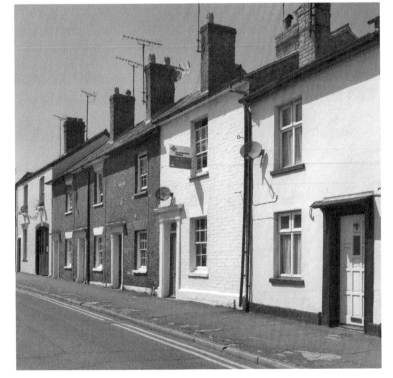

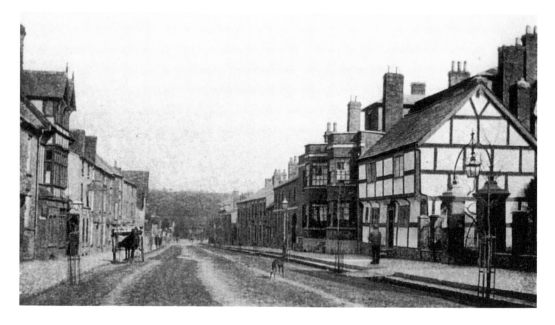

Lower Half of Etnam Street with Waverley House, 1900

The horse and cart stand outside the passage known as the Duke's Walk, opened by the Duke of Norfolk in 1792 to make it easier of the residents of Etnam Street to reach the Priory. The pub on the corner of the lane, the Duke's Arms, is almost as old. Briefly 'Gingers' in the 1990s it is now a private house, although it retains some of the pub signage around its door. Across the road are the imposing double bay windows of the Waverley Temperance Hotel, run at this time by Mrs Vernal. A decline in trade from commercial travellers led to its closure and the building became known to later generations as the town's youth club. It has since been rebuilt as a care home.

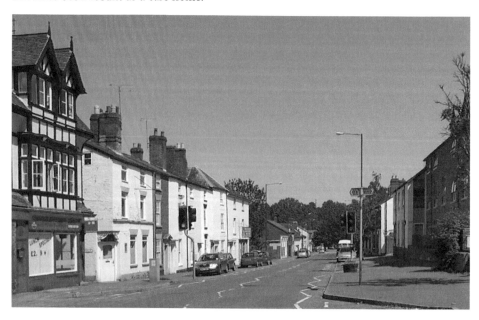

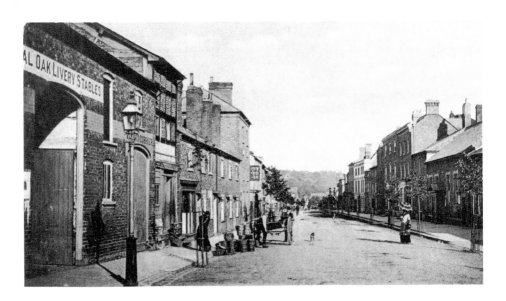

Etnam Street

The large sign for the Royal Oak Livery Stables is a reminder of a time when coaches would stop at this hotel. Even by the time of this photograph in the late 1800s this trade had largely ceased. It is perhaps fitting that this site is now a car park. The smaller archway next to this has the name Thomas Lloyd, currier (or leather worker) above the door. This is actually the rear access to his premises; the main building was in Corn Square. This archway originally gave access to the outbuildings at the rear of the King's Arms, an important inn at Corn Square in the eighteenth century. W. H. Smith's mainly occupies the site today. Beyond the archway is the White Swan public house, now a fish and chip shop. There is a reminder of its former use in the pub sign still visible facing school lane.

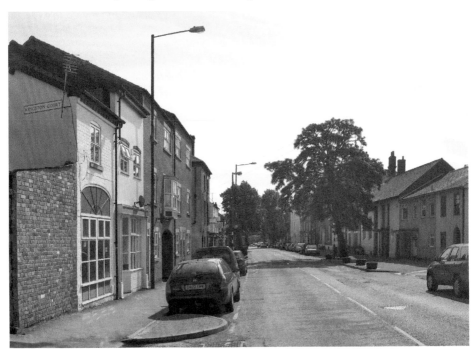

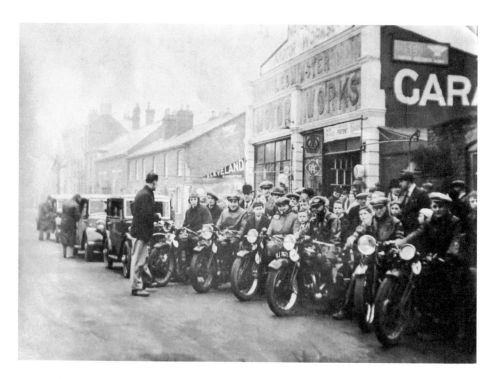

Watson's Garage with Motorcyclists

A group of intrepid motorcyclists draw an appreciative crowd of onlookers as they meet for a rally in the 1920s outside Watson's Leominster Motor Works in Etnam Street. Watson's still occupies the building; the distinctive pillars framing the doors are still there, although the elaborate signage has been simplified. At one time Watson's occupied three buildings in Etnam Street – this building, one across the road and the mission hall.

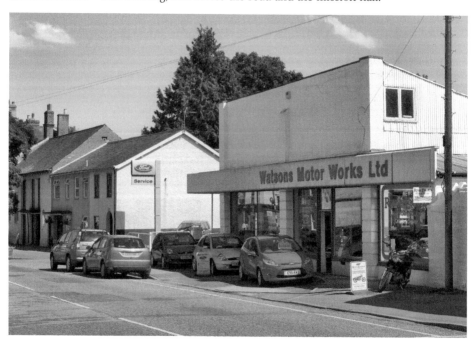

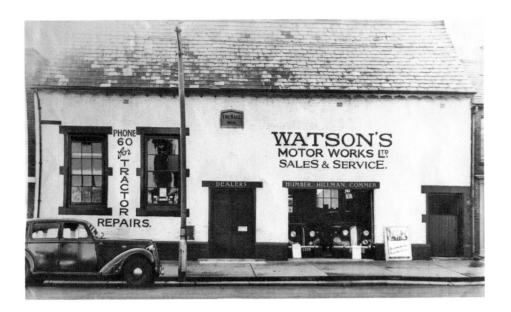

Leominster Museum

This building started life as a mission hall (*see page 34*) and went through a number of uses before eventually becoming a garage for Watson's Motors after the Second World War. It was sold to the Museum Trust in 1972 and now holds over 4,000 items related to the history of the town. The plaque above the door that shows the date, is now on display within the building. The museum is open during the summer months and is run entirely by volunteers.

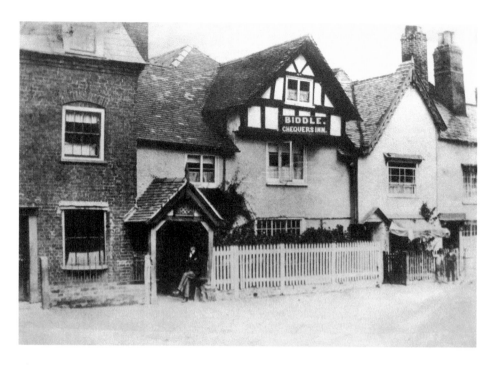

Chequers Inn, Etnam Street

James Biddle was landlord of the Chequers Inn when this photograph was taken between 1858 and 1879, although history does not record if he is the gentleman sitting in the porch. The Biddle family remained in the house up to the 1930s when Harold Job Biddle was the landlord. The building itself dates from around 1600 and, although extended and adapted over the years, has retained many of its original features. In 2007 it was named Herefordshire Pub of the Year by Campaign for Real Ale (CAMRA). The current landlord, pictured, is Bob Newman.

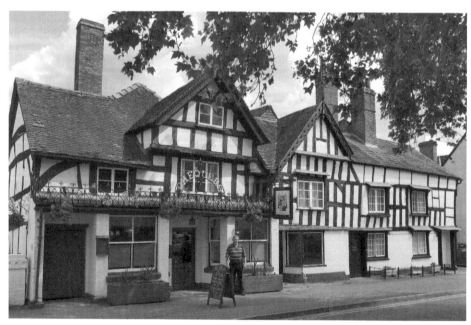

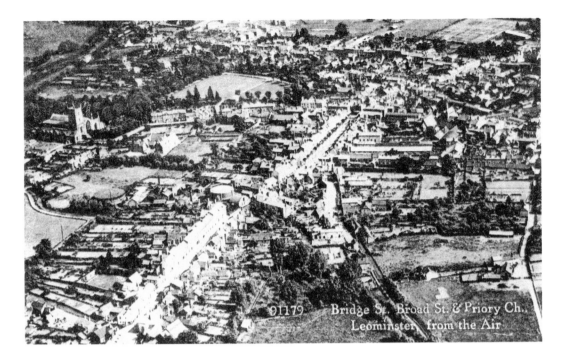

Aerial View

The older aerial view dates from the 1920s and shows the towns medieval street pattern, with the elongated burgage plots behind each house. However, change is on the way, and in the background is the newly built Craswell estate, at this stage still surrounded by open fields. By 2003 the change is extensive, and those who know the town will be able to spot the Dales offices (*see page 23*), the Sydonia Swimming Pool (*see page 37*), the Grammar school (*see page 81*) and Lambournes factory (*see page 87*) – which have all been redeveloped since this photograph was taken.

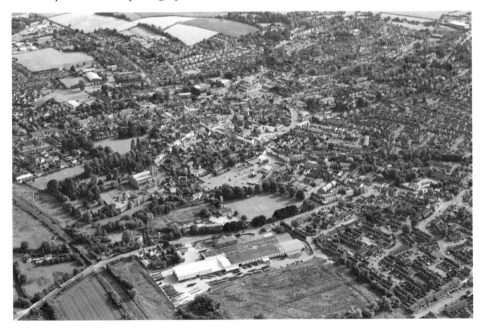

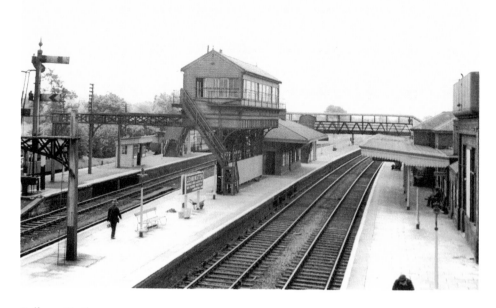

Railway Station

When this photograph was taken in the 1950s some of the five different railway lines that used the five-platform Leominster station had already closed. In its heyday, the station needed a large workforce and an elevated signal box to control the traffic. Today the signal box and all the lines apart from one have gone and the station is just a halt on the Hereford to Shrewsbury main line. However, thanks to a campaign by Leominster Council and the local Civic Trust, the station still has its Victorian buildings and canopy, although the new passenger bridge now dominates the view of the station.

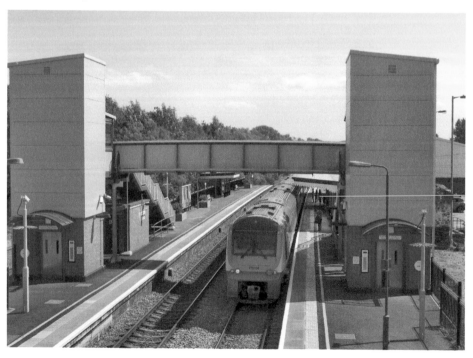

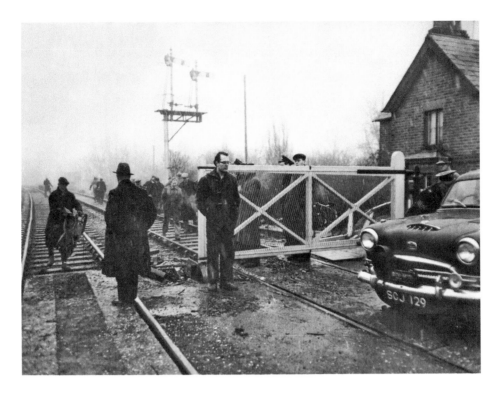

Level Crossing, Mill Street

Despite the fact that Leominster used to be a busy junction station, there were only two level crossings in the town. The crossing at the Broad on the Kington line closed to traffic in 1964. The other in Mill Street is still in use and is shown in these photographs. The scene from 1961 shows the aftermath of a derailment at this crossing. Just visible behind is the typical house provided by the railway company for the keeper. The gates converted to automatic operation in 1968.

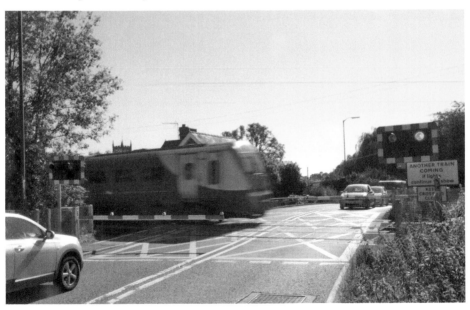

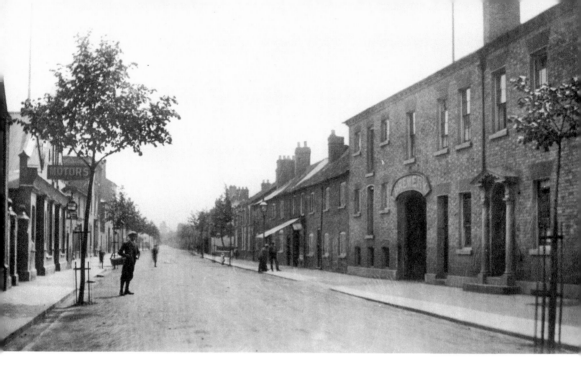

South Street and the Olympic Torch Relay

Many of the buildings in this photograph around 1910 are recognisable today. The young man returning home with his shopping stands outside the newly established Fryer's Garage. Across the road is the brewery with its distinctive archway. This was modified to become a Masonic Lodge in 1929, hence the sign set into the wall in the modern photograph. The swimmer Sharon Davies carried the Olympic Torch through this part of the town.

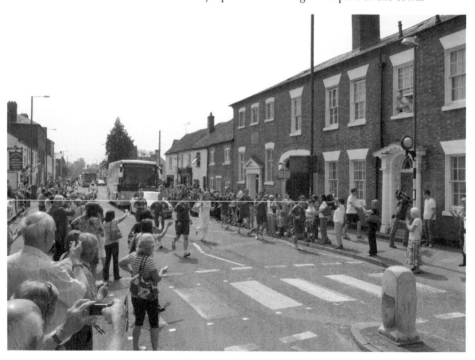

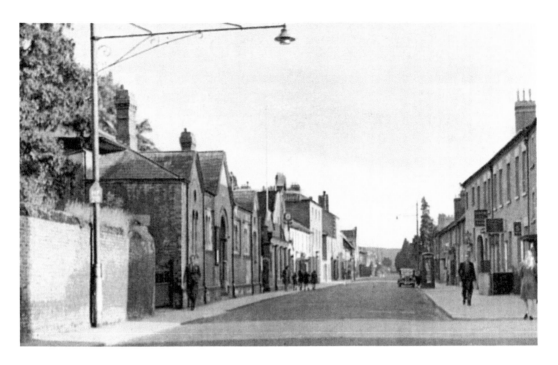

South Street

The view of South Street had not changed significantly by the 1940s. The building on the left was the Quaker's Meeting House, a highly influential force in the town in the nineteenth century and responsible for many social improvements. As the number of Quakers in the town decreased, subscriptions declined and in 1974 the building had to be sold. It is now a nightclub. Beyond is Fryer's Garage, now the site of the car park for the British Legion Hall.

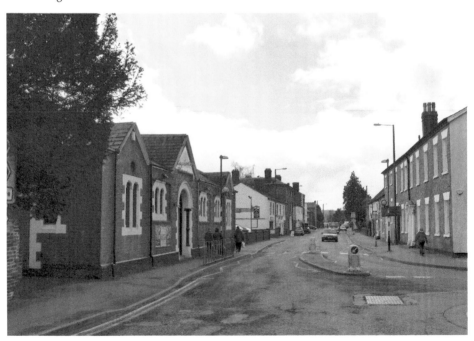

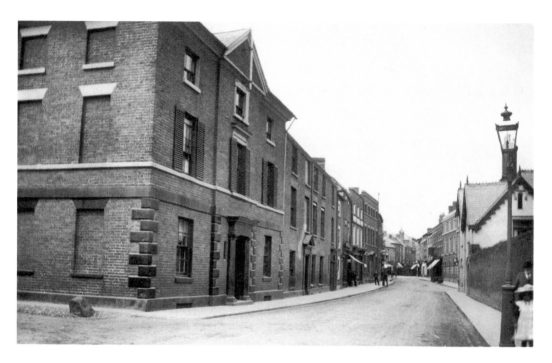

Cinema Site & South Street

When the picture was taken around 1900 these rather imposing buildings at 28 and 30 South Street housed offices for solicitor Edwin Preece Lloyd who served as Borough Treasurer and Clerk to the Commissioners of Taxes for Leominster District. The corner building was demolished and replaced in 1936 by the Clifton Cinema. The solicitors Lloyds & Cooper still practise from the remaining building. The street was not always as empty as the early photograph suggests. At times, the street would be full of people and animals during regular livestock sales. The large stone set into the roadside was to stop coaches cutting the corner and hitting the building.

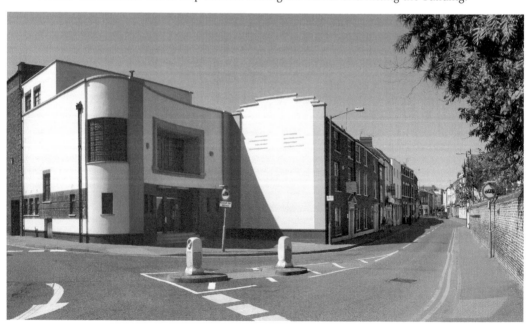

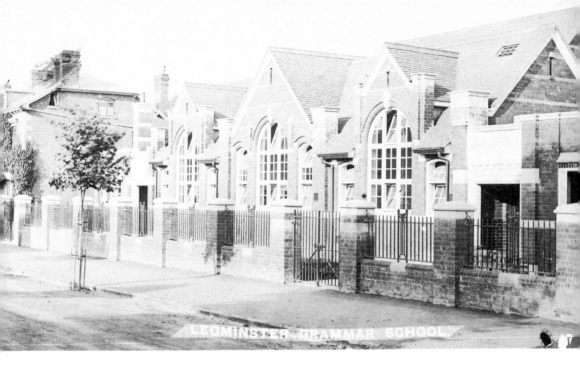

Grammar School

As a very successful exhibition at Leominster Museum in 2011 proved, the Grammar School in South Street is still remembered with great affection by its former pupils. In the early 1970s it was replaced by a new secondary school, which has just be completely rebuilt and renamed the Earl Mortimer College. The old Grammar School had not been used for a number of years and it was demolished, with only a section of wall retained as a reminder.

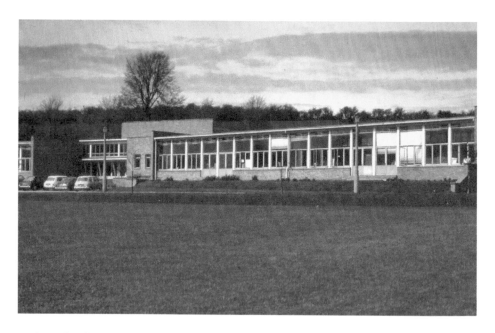

Junior School

This school is unusual in Herefordshire as a junior rather than a primary school. The infants have their own school nearby. This has been the pattern in Leominster for many years. Historically the younger children went to the junior school occupying the 'British' school in the Bargates, and the older seniors attended the National school in Church Road. This building was one of the many schools built in the post-war reorganisation of education, and is one of the largest in the county with more than 300 pupils.

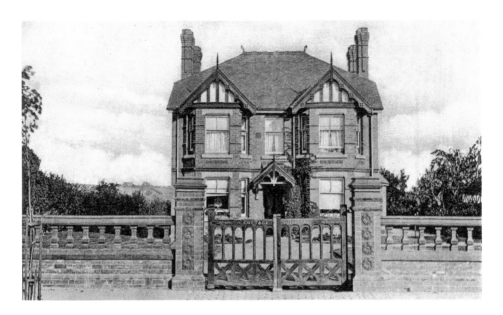

Cottage Hospital

The picture above shows the Cottage Hospital on South Street after the addition of an upper floor to the 1899 single-storey building. At this time, this was the nurse's home, which accounts for the birdcage on display in the open window on the left. There have been other alterations, first by the addition of wings to this building, and then a major extension to the rear. The people of Leominster have always supported the hospital. The proceeds of the first performance at the new cinema were donated to the hospital (*see page 80*) and each autumn, during the local hop harvest, many yards would have a hospital crib where pickers could donate part of their work. In the inset members of the adult school pose in the costumes they wore for a benefit event in 1911.

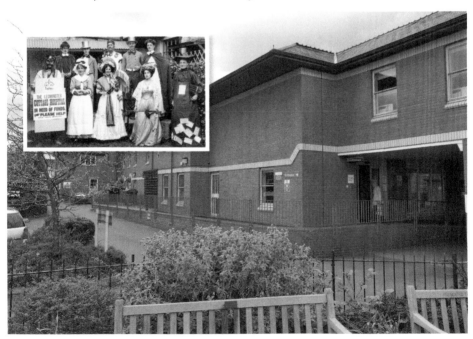

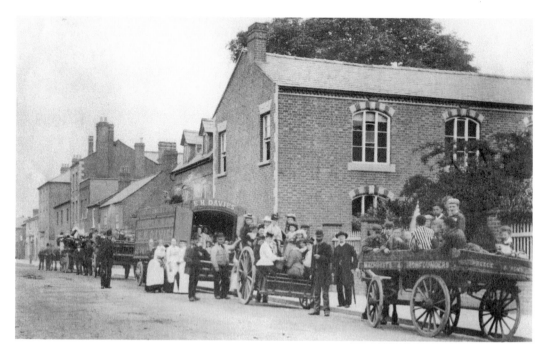

Moravian Chapel

Tracing their history back to 1415, the Moravians came to England in the early eighteenth century following persecution on the continent. The chapel in Leominster was consecrated in 1761 after members of the established church in Leominster formed a group that eventually affiliated to the Moravians. In this photograph around 1910 a group from the church, including the pastor, prepare for an outing. Although numbers have declined from their peak at this time, the church building is still used for services every Sunday.

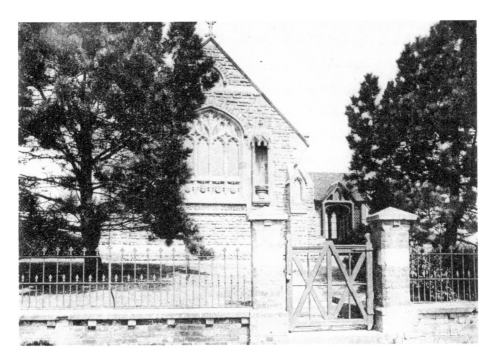

St Ethelbert's Catholic Church

Leominster Catholics worshiped at the former Wesleyan chapel in Burgess Street for twenty years before this new church was built in 1888. Designed by Peter Paul Pugin, this church is in the Gothic style pioneered by his father Augustus. As the niche on the west front is empty, this picture must have been taken before 1908; the statue of St Ethelbert by the Leominster artist W. G. Storr Barber was installed in that year.

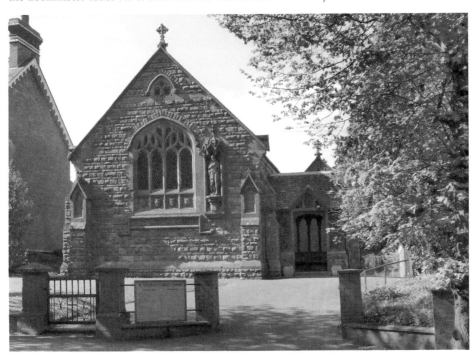

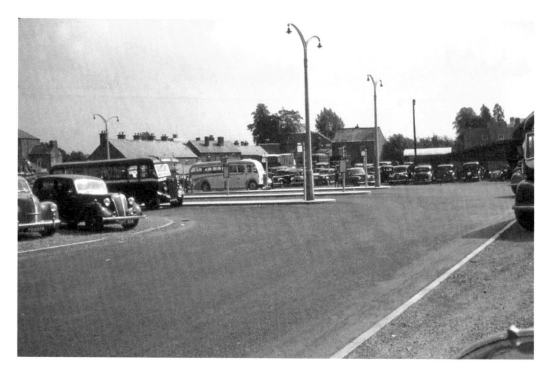

Coach Station

This view of the coach station in the 1950s has changed out of all recognition. Occupying the space between the New Exchange Buildings and Dishley Street, this station also incorporated a car park. Access to the site meant demolishing some fine old timber-framed houses on the Bargates. Ironically, when the coach station was moved from the site, this entrance was closed and today it is only used as a flowerbed.

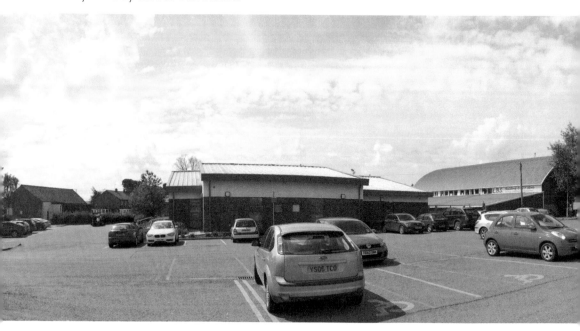

Westbury & Ryelands Road

It is difficult to date this picture precisely, but in the 1930s Mr Percy Bateman, owner of Bateman's Buildings (now Leominster Builders' Merchants) and twice mayor of Leominster, would occupy Mount Villa, the large house on the left. There are still residents in the town that remember the 3d piece he gave to each child in the town at Christmas. Lambournes occupied the open land on the left. A family business based in Birmingham, Lambournes came to Leominster in 1948 and moved to a purpose-built factory on this site in 1964, making accessories such as cufflinks, tie pins and cosmetic goods. The site has recently been redeveloped for housing.

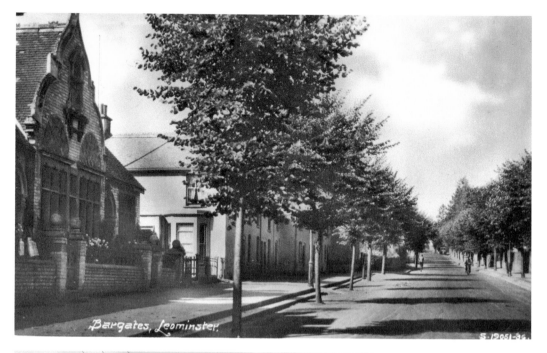

Bargates & Hester Clark's Almshouses

Founded in 1735 to provide accommodation for 'four decayed widows', these houses were rebuilt in 1874 and are still managed by the Almshouse charity today. The unusually decorated building has a plaque featuring an axeman on the front with the lines 'He that give away all before he is dead, let them take this hatchet and knock him on ye head.' This is supposed to refer to the financial difficulties caused to the founder by building the houses, so much so that she became an inmate herself.

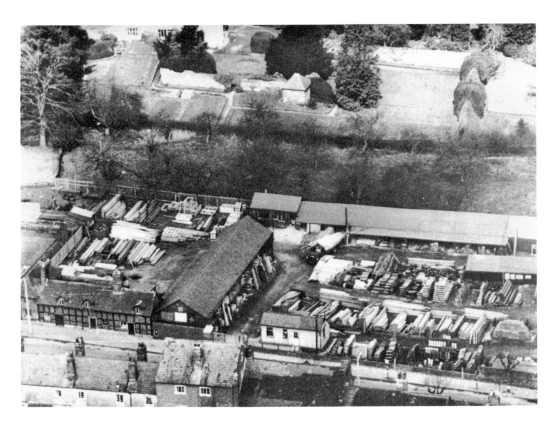

Timber Yard

Charles Norgrove first started business in Leominster as a linen draper, but by 1900 he had moved to Townsend House and established this timber yard and builders' merchant off the Bargates. Continuing until the the early 1980s, today the site has been completely redeveloped, and is now occupied by houses and a care home. The lower entrance to the home and the main entrance to the yard lie in roughly the same position.

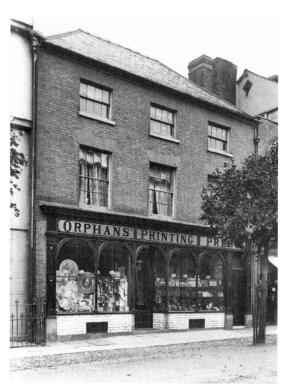

Orphans Press

Henry Newman and his Quaker friends established an orphanage in Leominster in 1869, and three years later it moved into purpose-built premises on Ryelands Road (shown in the inset, c. 1900). The orphanage closed in 1957 and the building was converted to flats. Newman established a printing press in Broad Street to train and educate the children and generate income for the orphanage. Following Newman's death in 1912 the Press became a private company. The building used by the Press at 10 & 12 Broad Street now houses an antiques shop. As Orphans Press approaches the 140th anniversary of its founding, and 100 years as a limited company, it has broadened its business to include design, digital printing and internet services at its new base in the Industrial Estate.

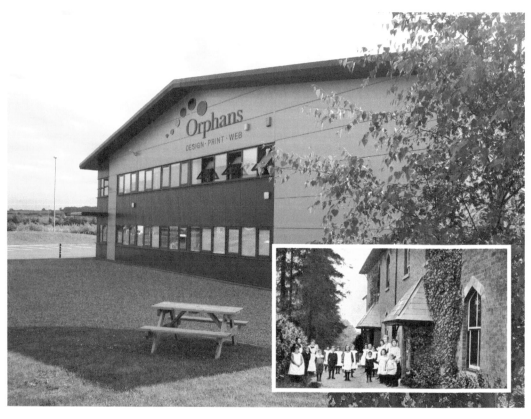

Brightwells

Brightwells are the oldest firm of auctioneers and valuers in the county, and have been a feature of life in Leominster since 1846. The centre of their business was the cattle market close to Dishley Street. It was near here that they built their auction house in the 1980s. In 2006 the company moved to much larger premises at Easters Court to the east of the town.

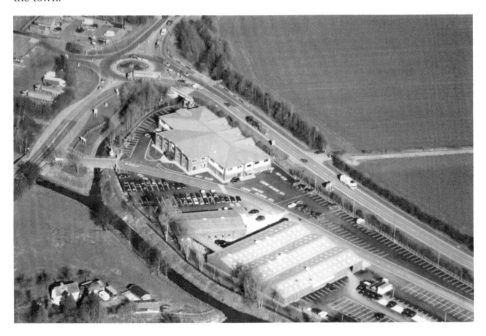

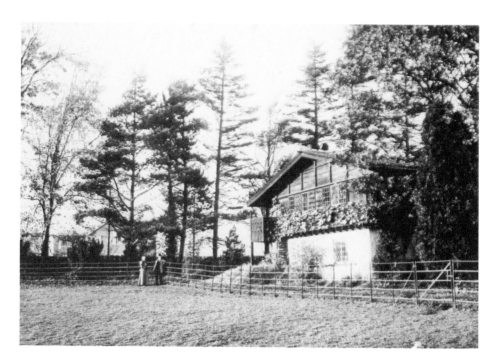

Swiss Chalet

This chalet was reputed to have been brought from Switzerland and rebuilt in the grounds of the Sheiling on Stockenhill Road by the Neild family. The house in the background is probably the 'Vista', also owned by the Neilds. Both these properties have now been replaced by housing development. The paddock in which the couple are standing occupied the apex between what is now Newlands Drive and Stockenhill Road.

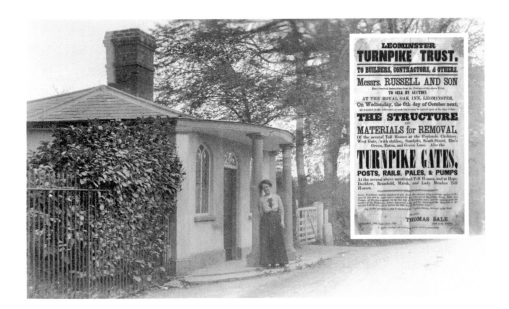

Toll House Ryeland Road

Most of the roads around Leominster were brought under the control of a Turnpike trust in 1729. This meant that private finance could be used to improve the roads and travellers could be charged for their use. This toll was collected at a gate on the stretch of road for which the trust had responsibility, and distinctive houses were built to house the gate keeper. The toll house on Ryelands Road was one of six around Leominster. They were all sold in 1869, made redundant by the coming of the railways, and then eventually most were demolished.

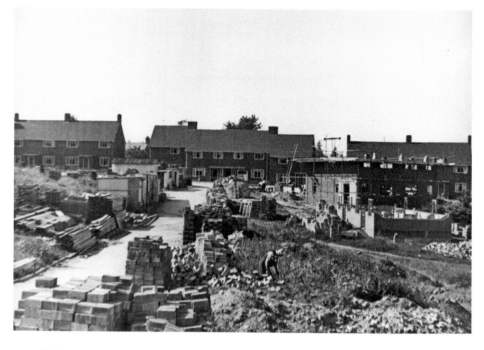

Westfield Estate

In the 1960s, the Birmingham Overspill Plan earmarked land to the west of Leominster for development under a scheme to build houses in the country rather than the city itself. When the plan was abandoned, land became available for development and, subsequently, the Council built this large estate. It took its name from Westfield Walk – a lane joining Ryelands Road to the top of the Bargates.

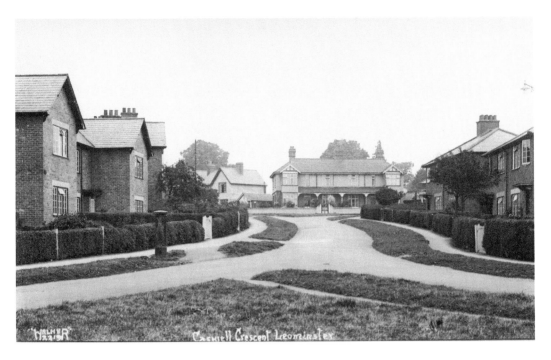

Caswell Crescent

The houses of Caswell Crescent, Terrace and Road make up the first small estate of 'suburban' semi-detached housing built in town in the 1920s. Initially, the houses did not have electricity and were only connected to the town's gas supply, which had to be paid for by coin-operated meters. However, these were solid-built houses, and after nearly a century, they still look as good as they did when they were built.

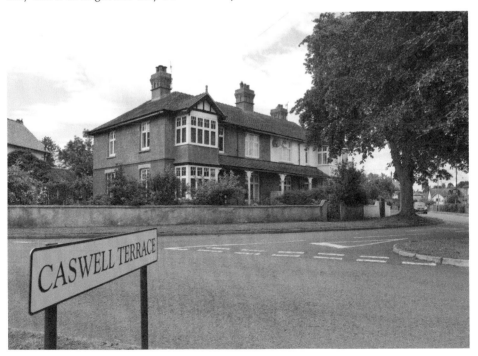

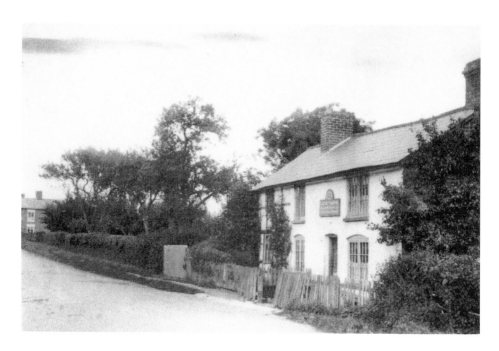

Barons Cross Inn

There were two inns at this junction entering the town from the west. The Baron's Cross Inn was originally an unpretentious cottage. The sign above the door, with the name of Edward Stanton as landlord, dates the picture between 1880 and around 1900. Further down the road stands the Brickmaker's Arms. This was built by Edward Tunks, who also had the nearby brickworks – hence the name he gave the pub. Soon after, he converted to the Mormon faith and emigrated to America. The pub became the 'Birdcage' in around 1900 and, after some time as a restaurant, it is now a private house.

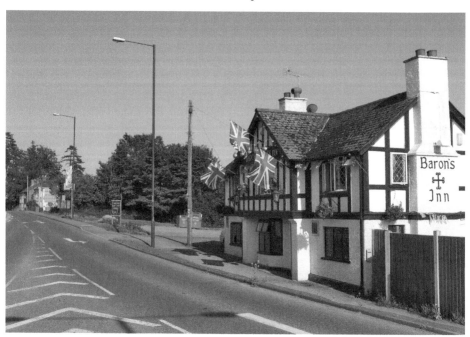